IMAGES
of America

HOMEWOOD

Martha Wurtele and Jake Collins

ARCADIA
PUBLISHING

Published by Arcadia Publishing
Charleston, South Carolina

Printed in the United States of America

Library of Congress Control Number: 2015940360

For all general information, please contact Arcadia Publishing:
Telephone 843-853-2070
Fax 843-853-0044
E-mail sales@arcadiapublishing.com
For customer service and orders:
Toll-Free 1-888-313-2665

Visit us on the Internet at www.arcadiapublishing.com

*We dedicate this book to Mr. Herb Griffin, who works tirelessly
to preserve the history of our wonderful city, Homewood*

IMAGES
of America

HOMEWOOD

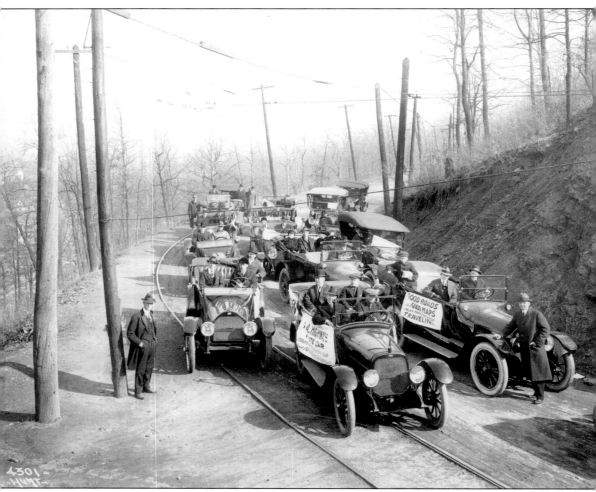

Promoted by the *Birmingham Ledger*, this caravan, pictured in 1910, pauses at the top of Red Mountain on what is now Eighteenth Street. It was headed for Montgomery in what was called "The Good Roads Tour." In the lead car are Dr. James E. Deadman, the passenger in the front seat, and attorney Charles Rice, in the backseat directly behind Deadman; Rice would soon become "The Father of Homewood." (Courtesy Special Collection, Samford University Library.)

ON THE COVER: In 1921, George "S.G." Shaia (right), an immigrant from Lebanon who arrived on Ellis Island in the early 1900s. Through hard work selling goods door-to-door, he was able to save enough money to purchase several lots along what became Eighteenth Street in downtown Homewood. Shaia opened a store that carried a large variety of goods, including drugstore items, cigarettes, drinks, and clothes. In 1932, his son Alex John "A.J." Shaia (left) took over the store and began working to convert it into a department store specializing in fine clothes. (Courtesy the Shaia family.)

CONTENTS

ACKNOWLEDGMENTS

In 1984, Lucretia Somers, director of the Homewood Library, encouraged Martha to start interviewing the older members of the early Homewood families. The Bryant, Wilbanks, Clasen, Hallman, and Liles families shared not only stories, but photo albums as well. Ethel Liles shared photographs taken by her father, John W. Dawson. Pierce Graves, another photographer, took many of the photographs in this book that are now part of the Wurtele Collection. Beck Wilson generously shared the collection of his father, Jimmy Wilson. Ray Cunningham, Charlie Lane, Truman Parrott, and Dr. Raleigh B. Kent have been of great assistance with photographs and important stories that bring life to the people in the images. Herb Griffin, Barbara Tubbs Pope, and Edward Perkins Montgomery Jr., descendants of some of the first settlers to the area, have provided photographs. Without their assistance, this project would not be possible.

The following books and publications were helpful references while compiling information for these photographs: the *Shades Valley Sun*; *Over the Mountain Journal*; Dr. Leah Rawls Atkins's *The Valley and the Hills*; Ray M. Atchison and Doris Teague Atchison's *Light in the Valley*; Annie Ford Wheeler's *Trinity United Methodist Church*; and Sheryl Spradling Summe's *Homewood: The Life of a City*.

We would like to thank several of the archivists who made this project possible. Jennifer Taylor and Elizabeth Wells of the Samford University Special Collection spent several months finding important photographs for us. Meredith McDonough, of the Alabama Department of Archives and History, provided wonderful, detailed images of some of Homewood's oldest treasures. We would like to especially thank Jim Baggett and Don Veasey, of the Birmingham Public Library, who worked tirelessly with us to locate historic photographs, particularly those of the board of equalization files. Without their help, it would have been impossible to piece together names and places that no longer exist.

Finally, we would like to thank the people of Homewood who have made this book possible, particularly the eighth-grade students at Homewood Middle School. Over the last three years, these students have traveled throughout the city, using these old photographs for a social media project. The interest they generated about these pictures allowed us to write this book.

The following photographic sources are credited by abbreviation in the captions: Alabama Department of Archives and History (ADAH), the Birmingham Public Library (Courtesy BPL), Special Collection, Samford University Library (SCSU), and the Wurtele Collection (WC).

INTRODUCTION

Before Homewood became the diverse, thriving city it is today, Shades Valley between Red Mountain to the north and Shades Mountain to the south was used primarily by Native Americans as hunting grounds. Bald Ridge, which runs east to west through the middle of the valley, provided stone and rocks for tools. In the 1820s, Daniel Watkins settled near what is now Rosedale, before moving east. Early federal land-grant records list other settlers: Stripling Byars (1825), John Byars Sr. (1834), and Nathan Byars (1836). The 1850s brought Elijah Brown and William D. Satterwhite, who settled near the Lakeshore Estates, followed by Phillip Thomas Griffin in 1858, who owned 160 acres extending from Shades Creek to Oxmoor Road, between what is now Interstate 65 and Old Columbiana Road. Oxmoor Valley, in the far western edge of Homewood, was a thriving community until the end of the Civil War.

Tombstones in Homewood bear the names of those who fought in the Civil War on the side of the Confederacy. Augustus Morris, James Massey, and others made their home in the Shades Valley after the war. Union Hill Cemetery includes the graves of 28 Confederate soldiers. Settlers continued to trickle into the valley in the late 1800s, including John Archibald Kent, who drove cattle from his home in Tennessee in 1899 to what is now west Homewood.

Shades Valley remained a rural area until the boom of Birmingham in the 1880s. Benjamin F. Roden headed a group of entrepreneurs and formed the Clifton Land Company to develop land "over the mountain." An impediment to development in the valley was the lack of a good road through Lone Pine Gap (where Vulcan is today), Walker's Gap (today's Greensprings Highway), or Red Mountain Gap (Cahaba Road). In order to remedy this, in 1889, the Red Mountain Railroad Line began transporting people through Lone Pine Gap into the valley. That same year, Roden reorganized the Clifton Land Company as the South Birmingham Land Company and divided the lots in Clifton to sell to the black population employed in the mines. John Henry Jones, a black merchant, purchased some of this land and built an imposing, two-story structure near the current site of Union Baptist Church.

In 1890, Theodore Smith began investing in lots in Clifton and was instrumental in changing the name to Rosedale. He convinced Damon Lee to leave his home in Russell County, Alabama, and bring his family to Rosedale. Smith and Lee worked closely together to make Rosedale a successful community. Beginning in the early 1900s, other families began to pour into Rosedale. The Hallmans purchased land on the north side of the Oxmoor-Irondale Road, fondly known as "Hallman Hill." Also moving into the area were the Cunningham, Lewis, Ogelsby, Saulter, and Shaia families.

Stephen Smith and Troupe Brazelton, seeing an investment opportunity in Shades Valley, purchased 1,700 acres for a new subdivision, Edgewood. Smith built a magnificent home on Oxmoor Road near the intersection of Broadway Street. Smith and Brazelton organized the Birmingham Edgewood Electric Railway, which provided transportation from South Highland, in Birmingham, to Edgewood, and eventually to the centerpiece of the new community, Edgewood Lake.

The townships of Rosedale and Edgewood continued to grow in the 1920s. When families of Grove Park approached attorney Charles Rice to help them create their own town, he saw an opportunity to incorporate all three towns into one city. Homewood was established in 1926 and was named for Edgewood's slogan, "City of Happy Homes." Rice served as the first mayor and is considered "the Father of Homewood." Red Cunningham was the first police chief, and Bill Knox was the first fire chief. The city of Hollywood, developed by Clyde Nelson, joined Homewood in 1929.

Edgewood Presbyterian Church, Oak Grove Cumberland Presbyterian Church, Union Baptist Church, Friendship Baptist Church, and Bethel AME Church in Rosedale have been in existence since the turn of the 20th century. Churches along Oxmoor Road—Our Lady of Sorrows Catholic, All Saints' Episcopal, Trinity United Methodist, and Dawson Memorial Baptist Church—have emerged as leading churches in their respective denominations.

As progress boomed in Homewood after World War II, Birmingham pushed for annexation. Thanks to city attorney Irvin Porter, city council president Sax Lawrence, John Smith, and the Homewood Chamber of Commerce, Homewood was able to defeat annexation and remain an independent city. Robert G. Waldrop became the mayor in 1968 and purchased available land west of Homewood. By developing the newly acquired land, Waldrop laid a foundation for Homewood that would ensure future financial success for the city.

Homewood saw unprecedented growth, not just in business and commerce, but also with the creation of an independent school system. The Homewood City School System, created on December 22, 1969, is Homewood's greatest accomplishment. Virgil Nunn was the first superintendent, and Michael Gross was the first principal at Homewood High School. Over the last 40 years, Homewood has won state championships in football, wrestling, soccer, indoor and outdoor track, cross-country, girls' basketball, and volleyball. Even more impressive are the academic achievements of the math and physics teams, which always rank high in the state. Homewood High School (HHS) also has one of the best fine arts programs in the country. With almost one-third of all HHS students in the band, fine arts are heavily emphasized. The band has performed in London (1990) and twice in Ireland (1993 and 1997), where its was declared the Best Dressed Band and the Grand Champion at the St. Patrick's Day Parade in Dublin. The band has participated in several college football bowl parades, highlighted by trips to the Tournament of Roses Parade in 1984, 2003, 2009, and 2014. Perhaps the greatest achievement is that it has participated in the Macy's Thanksgiving Day Parade more than any other school outside the New York area (1978, 1981, 1986, 1990, 1995, 2000, 2006, and 2011). Homewood has been named by the National Association of Music Merchants one of the best communities for music education every year since 2007. The school system is one of the main reasons that Homewood continues to thrive. Seeking to empower all students to reach their unique potential, Homewood cares for its citizens in a way that ensures success for decades to come.

Downtown Homewood underwent a dramatic change in 2004 with the SoHo development. SoHo Square, which includes boutiques, restaurants, condominiums, and Homewood City Hall, has allowed Homewood to be economically successful, and it will continue to foster growth in the city. Today, Homewood celebrates We Love Homewood Day every spring with a parade, games at Central Park, and a street dance in Edgewood. Every Fourth of July, downtown Homewood closes its streets as residents gather to watch "Thunder on the Mountain," a spectacular fireworks show conducted at Vulcan Park. The homecoming and Christmas parades though downtown are yearly traditions that highlight schools and local businesses. Homewood has adapted to the ever-changing culture of today's world while retaining a small-town atmosphere.

One

EARLY PIONEERS AND SETTLERS

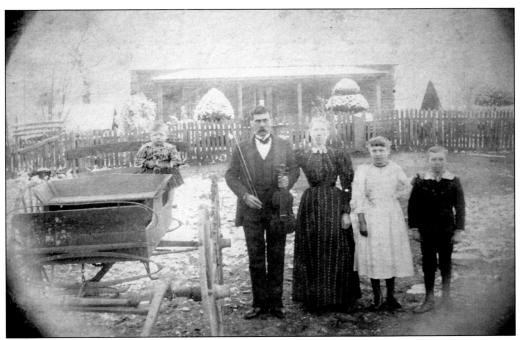

The Saulter family poses outside their log cabin, where the Samford University campus is today. Shown here around 1895 are, from left to right, Ellis J. Jr. (in wagon), Ellis Jerry Washington Saulter (with fiddle and bow), Sarah J. Morris Saulter, Ora, and James Augustus Saulter. Note the detail that went into the sculpting of the shrubbery. (Courtesy WC.)

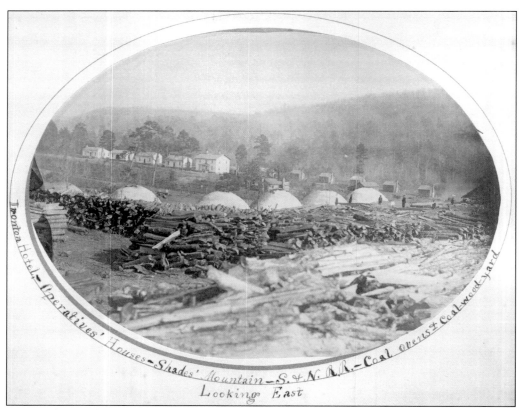

During the Civil War, the North had a decided advantage in industry over the South. Frank Gilmer and John T. Milner traveled to Richmond and convinced the Confederate government to finance a furnace to supply the arsenal at Selma, Alabama. Moses Stroupe and William McClune supervised the construction of the furnace. Oxmoor furnace went into operation late in the fall of 1863. It was run by 60 furnace men, along with 200–300 slaves, responsible for digging ore and cutting and hauling wood. Toward the end of the war, Brig. Gen. James Wilson's raiders, stationed at the Arlington Mansion, came over the mountain and destroyed the furnace. After the war, James Sloss, Daniel Pratt, and Henry DeBardeleben invested in the furnace. Oxmoor Furnace endured multiple additions and changed ownership several times before being torn town in 1927. (Both, courtesy ADAH.)

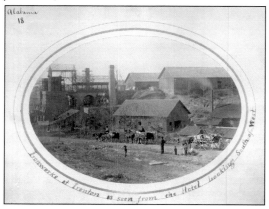

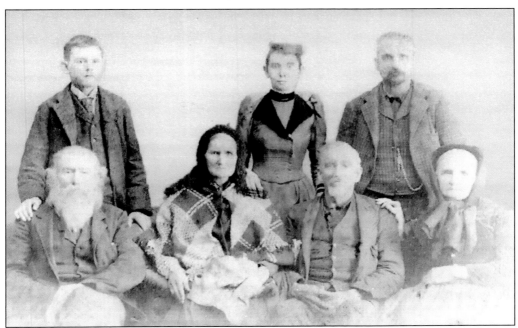

On February 2, 1846, Phillip Thomas Griffin (1818–1877) married Mary Anne Byars (1827–1895), the daughter of Nathan Byars. In the above photograph, she is seated second from left. Griffin traveled from the Carolinas, probably with the Watkins family, and made his way to Mississippi before deciding to come back to Alabama. According to US Land Office records, Phillip Griffin owned 160 acres in 1858, where Interstate 65 crosses Shades Creek today. The Griffins built their house, shown below, just off the Old Columbiana Road, near the current site of Publix. The family cemetery is just southeast of their home, on the north side of Acton Road. (Both, courtesy the Griffin family.)

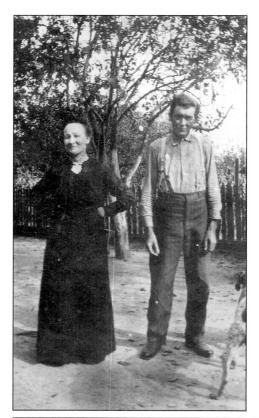

Charles Lafayette Griffin (born 1879) and his second wife, Edna, are pictured in front of their house on Old Columbiana Road. Charles was a truck farmer, growing tomatoes, corn, beans, and a variety of other vegetables. He sold produce to people all over Birmingham, including Damon Lee. In 1920, just before he died, he asked his son Franklin to fetch one more drink of water from the spring near the old homestead on Shades Creek. (Courtesy the Griffin family.)

The Cornelius family came to Alabama in the early 1880s. They settled on the land just west of Samford University, where Cornelius Drive turns north off Lakeshore today. Shown here are, from left to right, (first row), three unidentified, Felix Grundy Cornelius, and Harriet Boatwright Cornelius; (second row) Maurice Cornelius Ramsey, Claudia Ellis Cornelius, Charles S. Cornelius Jr., and two unidentified. (Courtesy Susan Williams.)

Charles Aaron Schomberg came to Birmingham in the early 1880s to work in the steel industry. After sustaining an injury that prevented him from working, he obtained property in the valley near today's intersection of Interstate 65 and Oxmoor Road. Pictured here are his granddaughters Jennie (left) and Ruth Schomberg (right) with one of their teachers from the Zelosophian Academy. (Courtesy Mark Roberts.)

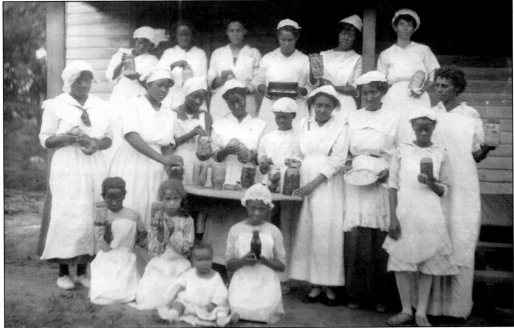

Most of the black workers in Birmingham could not afford to live in the city. The only affordable land in the late 1870s was on the south side of Red Mountain, in Clifton, which is now called Rosedale. Black residents have lived in Rosedale since that time. Women belonging to the Rosedale Homemaker's society are pictured here around 1890. (Courtesy ADAH.)

Robert Burell Edgerton (1863–1955), pictured here in front of his home on Nineteenth Place in what is now downtown Homewood, came to Rosedale in the early 1900s from Marion, Alabama. A former educator, he was well known for his excellent penmanship. When a young Damon Lee came to Rosedale, it was Edgerton who taught him how to keep accurate business records. (Courtesy Barbara Tubbs Pope.)

Theodore Smith (1849–1926) convinced Damon Lee (1870–1959), pictured here, to move his family from Eufaula, Alabama, to Rosedale. Lee opened a coal yard and, in 1909, opened one of the first stores in the valley, D. Lee & Son's Grocery. The store was located on the east side of Eighteenth Street in downtown Homewood, near the Bethel AME church. (Courtesy Barbara Tubbs Pope.)

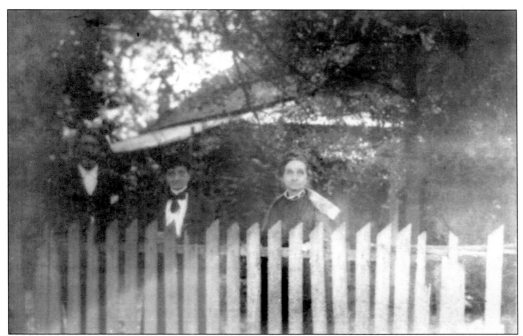

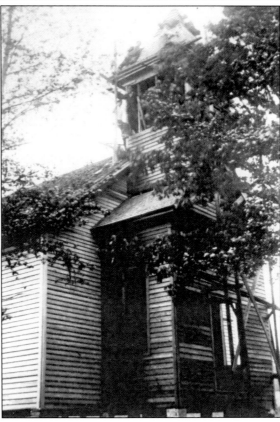

Pictured above, from left to right, are Marshman Byars, Kate Cummings, and unidentified. Cummings, who was from Mobile, Alabama, served as a nurse during the Civil War. She moved to Shades Valley, where she taught school and music classes in her home, near what is now Homewood Library. She continued to teach at the Rosedale Cumberland Presbyterian Church (right), which was organized in 1898 by Nathan Byars. It was located on Central Avenue, where Homewood Park is today. This church had a three-month summer school attended by many. It was told in later years that some of the students remembered that Miss Cummings would put her fingers on the coal dust and touch up her graying hair around her temples. (Both, courtesy WC.)

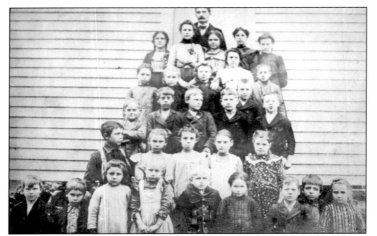

Students attending the three-month school at Rosedale Cumberland Presbyterian Church pose on the front steps in 1898. Willie Dawson is pictured at center in the first row. Among the others shown are Nora Lavada Dawson, Mattie and Henry Miller, Tom Cox, and Gus, Anna, and Charlotte Hallman. (Photograph by John W. Dawson, courtesy WC.)

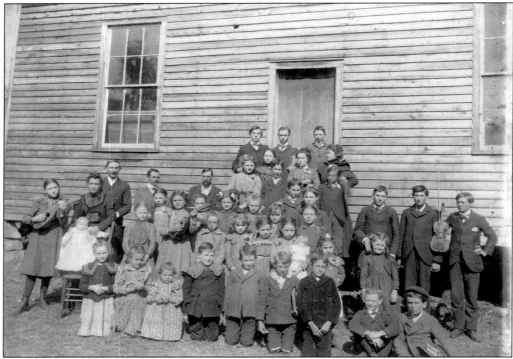

Students pose in front of the Rosedale Cumberland Presbyterian Church in 1902. Pictured are, from left to right, (first row) Charlotte "Lottie" Amelia Hallman, Ada Goodwin, Ludie Goodwin, Arthur "Art" Massey, Jesse Byars, David Williams, Jimmy Williams (no relation), John Albert Hallman, and Burt Rogers; (second row) Mignon Hall (with mandolin), Cileia Gardner Hall (with baby Ruskin), Anna Marie Hallman, Leona (Lewis) Jones (with mandolin), Vera ?, Etta Massey, Ressinger or Lolita ?, Eva Byars (with doll), Rozzie Byars, and Annie Massey; (third row) Professor Hall, two unidentified male visitors, Mande (Williams) Gardner, Leila Byars, Frances Massey (sister to Vera), ? Massey, Daisy Harrell, unidentified, and three Cox boys (one with violin); (fourth row) Annie Cornelius, Ada (Byars) Parker, Mack or Max Williams, two unidentified persons (possibly teachers), Clifton Byars, Ocie Harrell, and unidentified; (fifth row) Hugh Hall, Dan Cornelius, and Tom Byars. (Photograph by John W. Dawson, courtesy ADAH.)

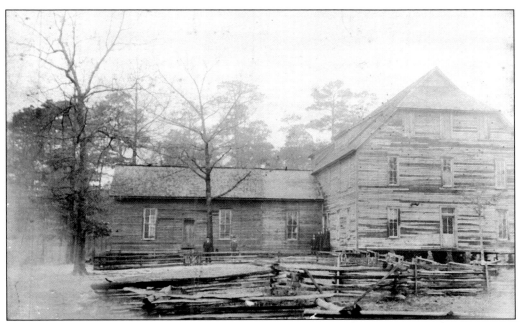

The Zelosophian Academy was founded in Oak Grove in 1892, at the intersection of Greensprings Highway and Oxmoor Road. The building was adjacent to Oak Grove Cumberland Presbyterian Church. The Reverend James Hugh Blair Hall was the master of the academy, which took its name from the Greek words *zelos* (zeal) and *sophos* (knowledge). The academy had a broad liberal arts curriculum and included first grade through college. Students who did not live close were given the opportunity to board in nearby homes. Dr. Hall's wife, Emma Cilein Gardner Hall, taught music and art. Tuition varied from $1.50 to $5 per month. (Both, courtesy ADAH.)

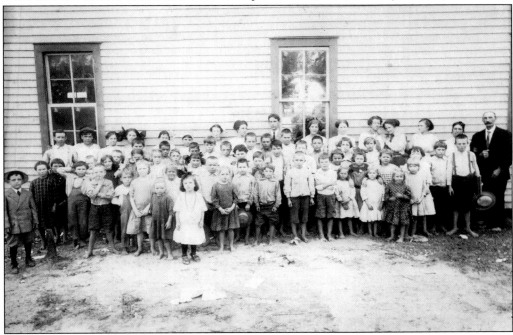

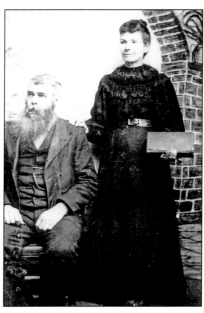

Rosedale Cumberland Presbyterian Church was organized in 1898, and a building was erected on land donated by Mr. and Mrs. J.N. Byars. The Reverend Lorenzo Dow Lewis, pictured here with his wife, Indiana Alabama Culpepper, was called as the first minister. Even though Lewis retired before the founding of Edgewood Presbyterian Church, he did fill in as an interim pastor there. (Courtesy Edgewood Presbyterian Church.)

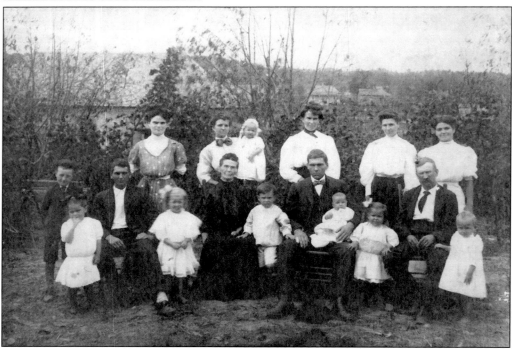

Pictured here are the children of the Reverend Lewis and his wife, Indiana. Willie Milligan Lewis (first row, third from left) and Oscar Witt Lewis (first row, seventh from left) worked in a machine shop in Bessemer. Once the Vulcan statue was moved atop Red Mountain, the Lewis brothers helped reassemble it. Robert Engle (first row, second from right) worked in Theodore Smith's greenhouse on Twenty-Eighth Avenue. This photograph was taken on the west side of the Lewis home, on Twenty-Eighth Avenue, in what is now downtown Homewood. (Photograph by John W. Dawson, courtesy Lisa Powers.)

In 1903, the Vulcan statue was commissioned for the 1904 St. Louis World's Fair. After being disassembled (in St. Louis), it was reassembled at the fairgrounds in west Birmingham before finding its final home atop Red Mountain. The citizens of Homewood laugh at being the "butt" of many jokes. It comes from the fact that Vulcan does not have any pants and he moons the city. (Photograph by Pierce Graves, courtesy WC.)

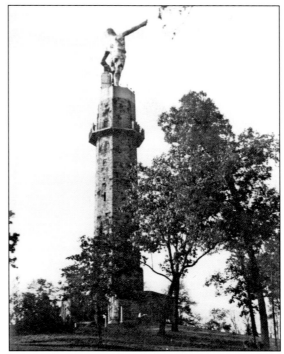

Robert Engle, who married into the Lewis family, worked in the Smith Greenhouse along Twenty-Eighth Avenue South, in what was then Rosedale. Legend has it that Rosedale was named for Theodore Smith's roses. However, his daughters disagreed, stating, "He grew more chrysanthemums than roses." (Courtesy Lisa Powers.)

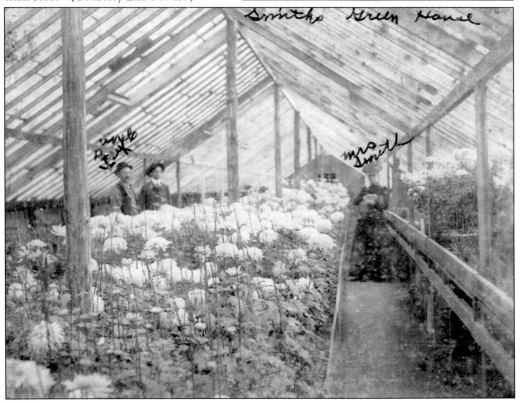

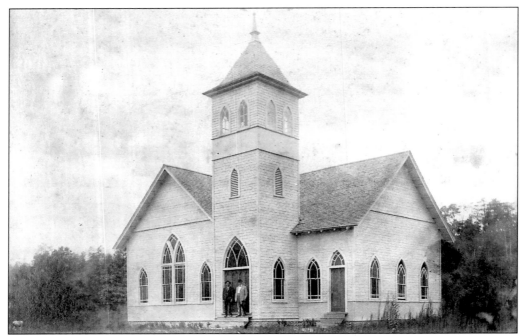

Edgewood Presbyterian Church was formed when Oak Grove and Rosedale Cumberland Presbyterian Churches merged in 1912. It was customary in those days for the members of the session to sit in judgment upon the morals of those under their care. Early records show that two girls were brought before the session for "tripping the light fantastic," known today as dancing. In 1919, the church changed its name to Edgewood Community Church to accommodate the vast array of Christians in Shades Valley who did not have churches to attend. In 1928, after the organization of Dawson, Trinity, and All Saints', the church resumed its former name. This white frame structure was torn down in 1953 and replaced by the current building. Note the cow grazing at lower left. (Courtesy Edgewood Presbyterian Church.)

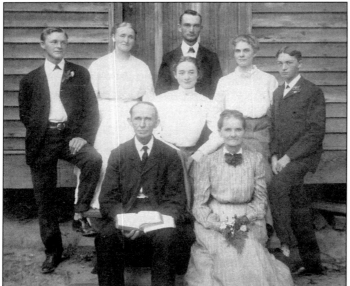

The Oglesby family ran one of the many dairies in Oak Grove. Their dairy provided milk for many of the families in West End. Reverend Oglesby came from Bibb County and served as pastor of Edgewood Presbyterian Church. Shown here are, from left to right, (first row) Rev. Samuel S. and Margaret "Stacy" Oglesby; (second row) Viola Oglesby; (third row) Oliver Earnest, Austelle, Samuel Argalus, Cora, and Milton Oglesby. (Photograph by John W. Dawson, courtesy WC.)

Samuel Argalus Oglesby and Ora L. Saulter pose on their wedding day, May 4, 1902. The Saulters gave them land and built a house across Oxmoor Road for the new couple. The land, part of the original Morris family grant, contains the old Morris Cemetery. Their home still stands as the only one on the north side of Oxmoor Road, just south of Palisades Boulevard. L.A. and Jesse Lambert now own the home and care for it as well as the cemetery. (Courtesy WC.)

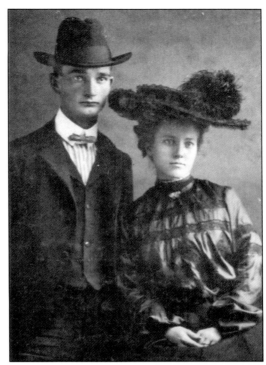

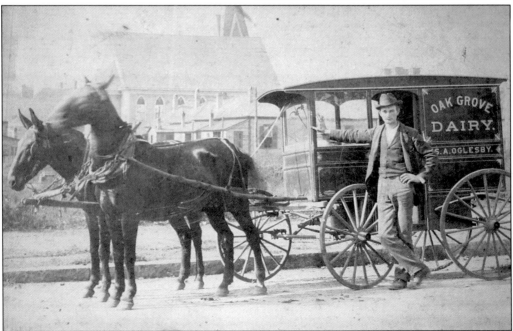

The Oglesby Dairy was one of the many dairies in Oak Grove. Farmers would rise early in the morning, sometimes as early as 2:30 a.m., to milk the cows, then bottle and deliver the milk on the same day. Here, Samuel Argalus Oglesby cuts quite a figure while delivering milk in West End. (Courtesy WC.)

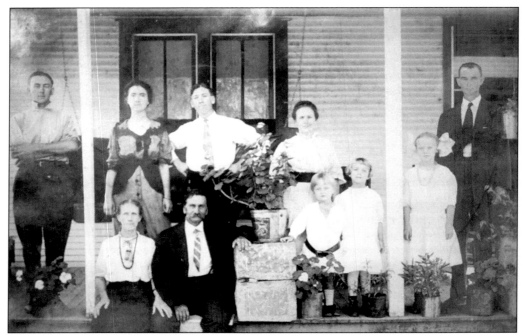

The house shown in these photographs was built by Ellis J.W. Saulter and completed in 1899. It was built from heart pine; its floors, walls, and ceilings used tongue-and-groove construction. This house, now at 523 Oxmoor Road, is one of the few remaining homes built in the 19th century in Homewood. Shown in the above photograph, taken around 1912, are, from left to right, (first row) Sallie Morris Saulter and Ellis J.W. Saulter; (second row) Ellis J. Saulter Jr., his wife, Maybell Miller Saulter, James Augustus "Gus" Salter, Ora L. Saulter Oglesby, Ellis, Estelle, Wilma, and Samuel A. Oglesby. (Both, courtesy WC.)

The church grounds near Oak Grove Cumberland Presbyterian Church provided a setting for young people to socialize after services. Here, James Augustus "Gus" Saulter is out of luck trying to catch a ride with two young ladies around 1910. It appears there is only room for two in their horse-drawn buggy. (Courtesy WC.)

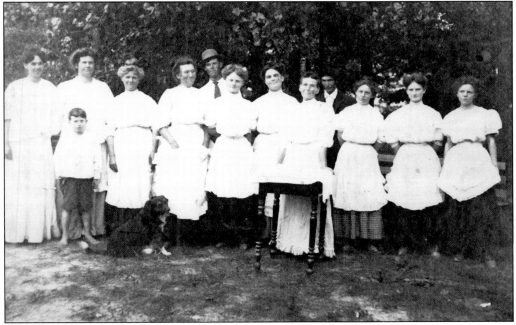

In the early 1900s, ice-cream socials were a popular way to raise money for the local church. Here, women of the Presbyterian church gather. They are members of the Lewis, Hallman, and Dawson families. (Photograph by John W. Dawson, courtesy WC.)

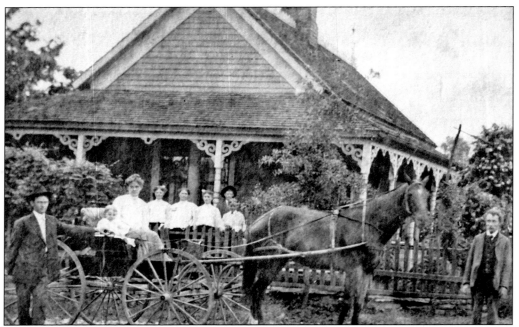

The extended Hallman family poses in front of their home on the northeast corner of Eighteenth Street and Oxmoor Road. In 1904, they purchased the house on Hallman Hill for $700; six Hallman children were raised there. Shown are, from left to right, Charlie, Hattie, Louise (Charles's wife), Anna, Carolina (Nylelom), Charlotte, John, Gus, and Anders Gustaf Hallman. (Courtesy WC.)

Posing here around 1900 are Charlie (left), Anna (center), and Gus Hallman. In the days before radio and television, families entertained themselves by making music. The Hallmans were very active in the Scandinavian Glee Club. A.G. Hallman sang tenor, Carolina sang alto, and Anna Marie played the organ when they met at the Hallman home. (Courtesy the Hallman family.)

Hallman family members gather on May 15, 1910, the morning of Anna Hallman's wedding to George G. Clasen. Shown are, from left to right, (first row) Carolina and Anders Gustaf Hallman; (second row) John, Charlotte, Gus, Anna, and Charles Wilhelm Hallman. (Courtesy WC.)

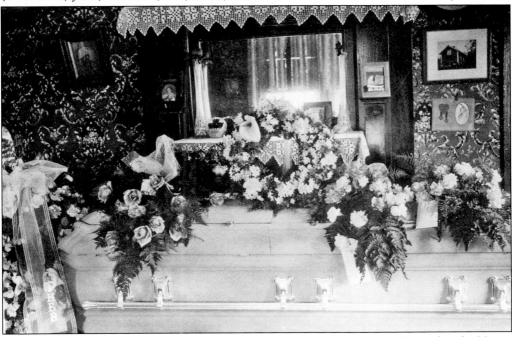

Anders Gustaf Hallman died on March 26, 1924, and was buried just down the road in the Union Hill Cemetery next to Union Hill Church. This is his casket, laid out in the parlor of the Hallman home. Such arrangements were customary in the days prior to the establishment of funeral homes. Ironically, this is the present location of Ridout's Valley Chapel funeral home. (Courtesy WC.)

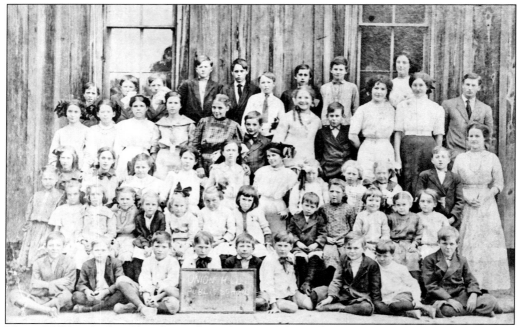

Union Hill Methodist Church was formed as Irondale Methodist in 1867. It was moved next to the cemetery in 1873, and the name was later changed to Canterbury Methodist Church. In 1950, the church moved to Mountain Brook. Friends and families of Union Hill Cemetery continue to place flags in the graveyard, where many of the first settlers of Shades Valley are buried. Union Hill also served as a school, which many of the Hallman children attended in 1911, the year of this photograph. (Courtesy the Hallman family.)

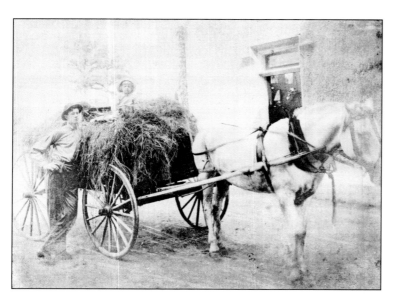

In 1907, Vernon "Red" Cunningham, 18, and his nephew Frankie Macke, who is atop the wagon, delivered hay to Elmwood Cemetery. It must have taken them all day, as they traveled to the cemetery and back along the Oxmoor/Montevallo Road. (Courtesy Ray Cunningham.)

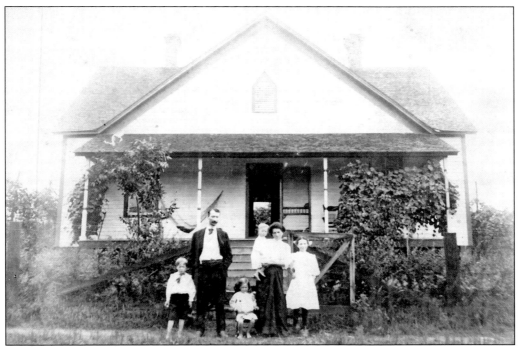

An unidentified family poses in front of the Cunningham house on Twenty-Eighth Avenue in what is now downtown Homewood. According to the 1900 federal census, Samuel F. Cunningham was a sexton for the City of Birmingham. Their farm was located where Lane Park is today. When Lane Park was established, they had the first concession stand. (Photograph by John W. Dawson, courtesy WC.)

Posed on a large fallen tree are, from left to right, Mattie Cunningham Macke, "Shug" Cunningham, an unidentified friend, and Sally Cunningham. Almost as amazing as their having climbed atop this tree is the fact that they did it without soiling or tearing their clothes. (Courtesy Ray Cunningham.)

Making music was a very important form of entertainment before the advent of radio and television. Someone in almost every family played an instrument, and many in the valley were taught by William Webb Cox. Shown here are, from left to right, W.W. Cox, Leah Smith Cox, Bedford Henry, Giles, William Lenox, and Thomas Enoch Cox. (Photograph by John W. Dawson, courtesy WC.)

Pete Fox (center), a patternmaker for Belcher Lumber Company, built this house in 1900. He and his wife, pictured here with their 10 children, made all of the doors and windows. They also hand-carved the wood mantles that decorated the fireplaces. Formerly occupied by Zanaty Realty Appraisers, the house looks much the same as it did when it was first built. (Photograph by John W. Dawson, courtesy WC.)

The Bailey family lived in a house next to the cemetery, near the intersection of Oxmoor Road and Greensprings Highway. Reverend Bailey was an itinerant Baptist preacher who started several churches in Alabama, including some in Shelby and Jefferson Counties. He and his wife are buried next to each other in unmarked graves in Bailey-Sellers Cemetery, just behind the Paw Paw Patch off of Greensprings Highway. Posing in the photograph are, from left to right, Minnie Tyler, Sarah Harrell and baby, Luther Bailey, Dan Acton Bailey, Bennie Bailey, Laura Frances Sellers Bailey, and Rosa Mae Tyler. (Courtesy the Griffin family.)

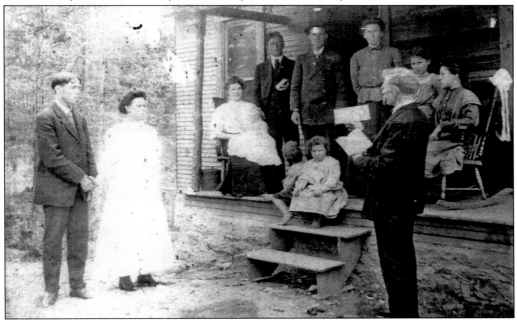

The Reverend Dan A. Bailey performs the wedding ceremony of an unidentified couple in front of his home. On the porch are, from left to right, Rosa Mae Tayler Bailey holding her baby, Annie Laura Bailey; Will Bailey; Walter Dawson; LaMaggise Ann Dawson; Hattie Dawson; and Lawada Dawson. On the step are Tommy Dawson (left) and Ethel Dawson. (Photograph by John W. Dawson, courtesy the Griffin family.)

John W. Dawson, born in Georgia, followed his two older brothers to Shelby County, where they found work installing the new waterworks system. He married and started a family before moving in 1900 to Rosedale, where he worked as a carpenter and freelanced on weekends as a photographer. Here, his wife, LaMaggie Ann, and daughter Flora Olga pose for him. (Photograph by John W. Dawson, courtesy WC.)

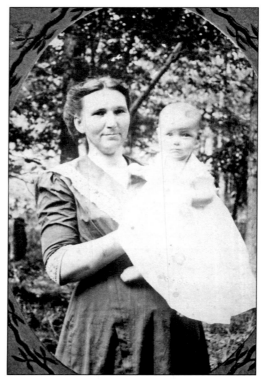

James William Ira "Willie" Dawson and his younger brother Seaborn pose outside the Dawson home off Old Montgomery Highway, near the current site of the Mayfair apartments. This would not be Willie's last trip home before going to fight in World War I. But it would be the last time his family would see him. (Photograph by John W. Dawson, courtesy WC.)

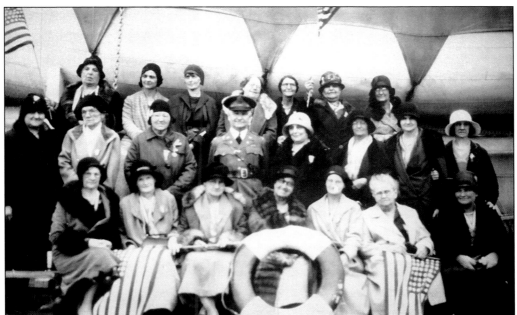

Willie Dawson joined the Rainbow Division in London, England, during World War I and died in France on October 18, 1918, just before the end of the war. In 1929, Congress enacted legislation that authorized the secretary of war to arrange for pilgrimages to the European cemeteries "by mothers and widows of members of military and naval forces of the United States who died in the service at any time between April 5, 1917, and July 1, 1921, and whose remains are now interred in such cemeteries." Dawson's mother is pictured on the left of the captain (above) on her journey to France to visit her son Willie's grave (right). (Both, courtesy WC.)

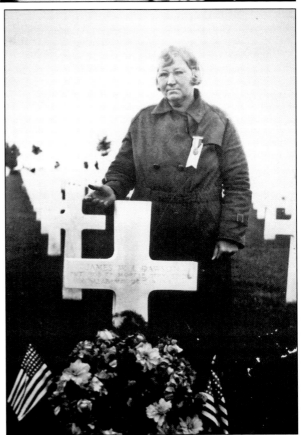

When the trolley line was built over Red Mountain, the county reserved an 18-foot right-of-way for cars, enabling Dr. James Allen Meadows to be one of the first doctors to serve in Shades Valley. Dr. Meadows is seen here with his daughter Josephine and an unidentified child. (Photograph by John W. Dawson, courtesy WC.)

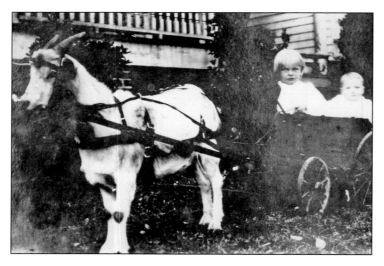

Young children were kept near the house, where they could be watched closely. A goat cart, such as this one, allowed mothers the freedom to move from one place to another by simply leading the goat. Pictured are Wilma (left) and Estelle Oglesby outside the Morris home on Columbiana Road where Oak Grove Cumberland Presbyterian Church is today. (Courtesy WC.)

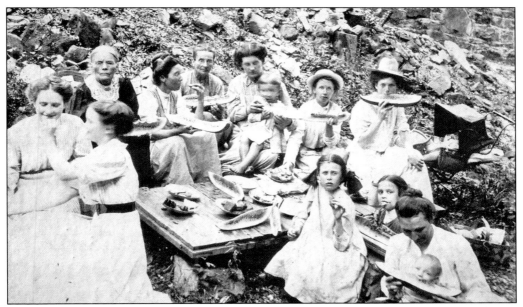

These people have gathered to eat watermelon near the intersection of old Highway 31 and what became Lakeshore Drive. When the wells ran dry, people would walk to the natural spring to get water. A company from Birmingham eventually bottled and sold water from that spring, until the health department dynamited the facility. Mrs. Dawson is pictured at bottom right. (Photograph by John W. Dawson, courtesy WC.)

Another social spot in the early days of Shades Valley was the Odd Fellows Lodge, near the intersection of Oxmoor and Oak Grove Roads. Raleigh B. Kent remembers playing in the abandoned lodge in the early 1930s and trying on the robes and capes. (Courtesy the Griffin family.)

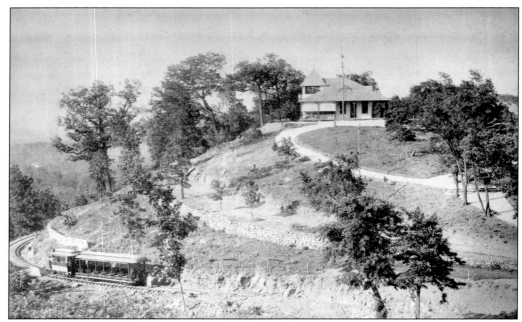

In order to encourage people to live "over the mountain," the Red Mountain Railroad Line opened up in 1889. The line started near Fourteenth Street South and came over the mountain into Clifton along Central Avenue. The Red Mountain Casino was built to attract customers, but neither the casino nor the railroad line was successful. The Red Mountain Railroad Line closed in 1893. (Photograph by O.V. Hunt, courtesy Jimmy Wilson.)

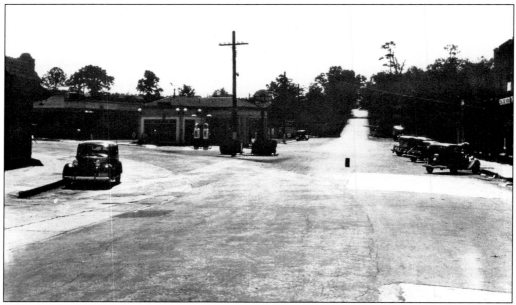

This view of "The Curve" on Eighteenth Street in downtown Homewood shows just how rural the town was prior to the war. When this photograph was taken, the south end of Eighteenth Street was lined with houses. It is today occupied by businesses. (Photograph by O.V. Hunt, courtesy Jimmy Wilson.)

Shown in the above photograph are Troupe Brazelton (second from left) and Stephen Smith (third from left). They formed the Edgewood Highlands Land Company, which purchased 1,700 acres in Shades Valley. Edgewood was plotted within a 200-acre portion of this land. In order to develop and sell land in Edgewood, the company needed easy transportation available for prospective homeowners. On August 28, 1909, efforts began to build the Edgewood Electric Railway. The streetcar traveled the length of Manhattan Street, turned south down Evergreen Avenue, and then took a sharp right on Oxmoor Road at this intersection before heading south again on Broadway Street. Smith built the home pictured below for himself from 1909 to 1910 on Knob Circle. It was built as a selling point in order to try to convince people to move to Edgewood. In 1920, he sold the house to John A. Coker. This property would not only play a vital role in the founding of Edgewood Baptist Church, but would also be a centerpiece of the Edgewood neighborhood. (Both, courtesy the Griffin family.)

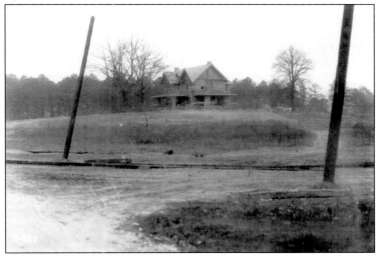

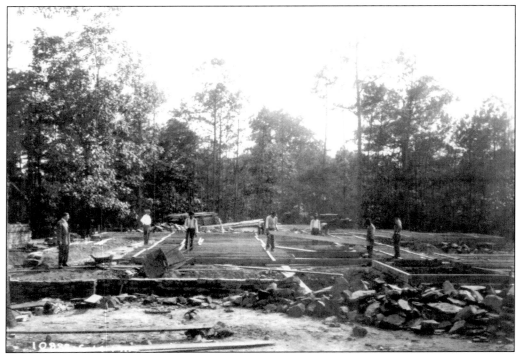

Construction began on the Edgewood Country Club in 1911, near what is now Lucerne Boulevard where it intersects with Riviera Road. The club was intended to be an added feature with Edgewood Lake, which was created by damming Shades Creek near Old Columbiana Road. Above, workers lay the footings for the building. Below, although automobiles were in use at this time, much of the work was completed with horses and mules. (Both, photograph by Bert G. Covell, courtesy the Griffin family.)

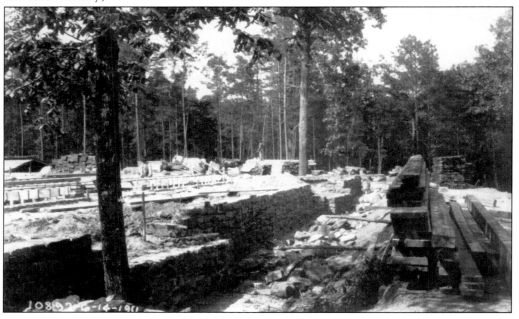

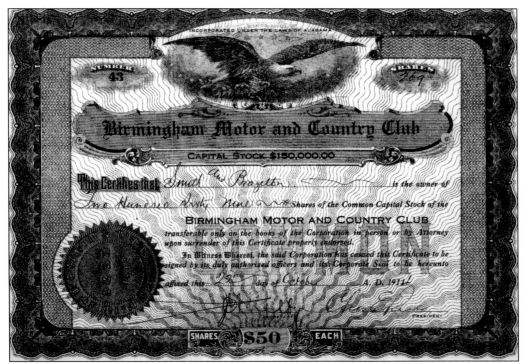

Led by Charles Rice, the Birmingham Motor & Country Club purchased the property, and the club was completed by 1914. This certificate shows that Smith and Brazelton were the owners of 269 shares of stock in the company in 1914. Although the club was dissolved in 1923, it continued to operate as Edgewood Park, led by R.R. Rochelle. (Both, courtesy the Birmingham History Center.)

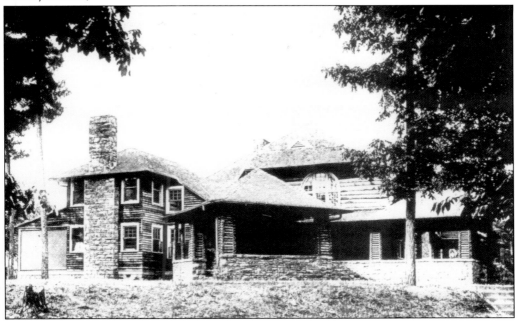

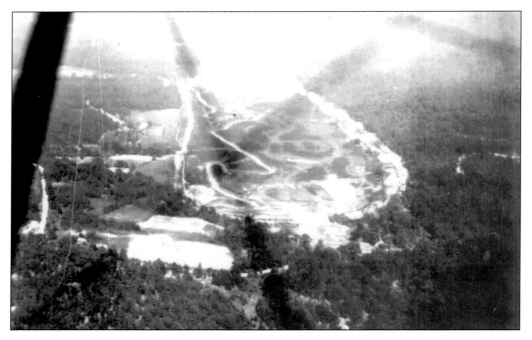

The north and south borders of Edgewood Lake were originally graded to be a racetrack, modeled after the speedway in Indianapolis. Although the track was never completed, the roads eventually became Lakeshore and South Lakeshore Drives. The below photograph shows the Edgewood Lake Pavilion on the south side of Lakeshore Drive where it intersects with Riviera Drive. Even into the 1940s, the piers of the Edgewood Lake Pavilion could be seen in the dry lakebed. (Both, photograph by O.V. Hunt, courtesy James Lowery.)

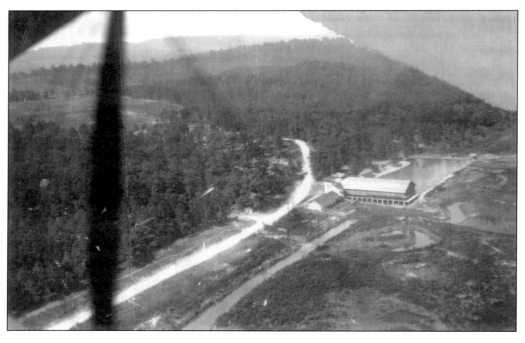

The Fourth of July was always a big celebration honoring the birth of the nation. At right, teenagers enjoy the cool water of the Edgewood Lake Pavilion overlooking Edgewood Lake around 1920. The children in the front of the group are, in no particular order, Fred, John, and William Schor. Below, the postcard shows the attractions of Edgewood Park, including a diving board, the Dreamland Dancing Pavilion, and a large swimming area. At the time this postcard was printed, Hugh Hill was the manager of the park. (Right, courtesy WC; below, courtesy Tim Hollis.)

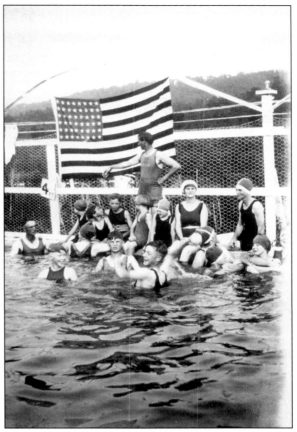

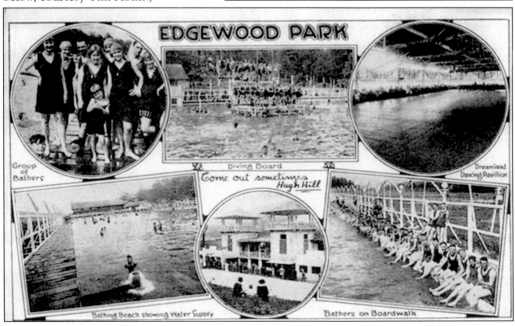

EDGEWOOD PARK

Group of Bathers

Diving Board

Dreamland Dancing Pavilion

Come out sometime Hugh Hill

Bathing Beach showing Water Supply

Bathers on Boardwalk

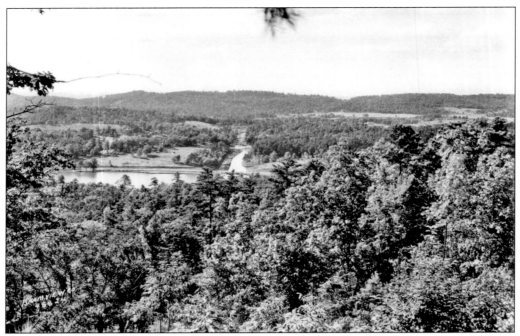

Looking north from Shades Mountain, this is a spectacular view of Edgewood Lake and the streetcar line that ran to the lake. When the lake was full, Griffin Brook would retain more water, and "Blue Hole" provided a wonderful swimming hole for Homewood residents. (Courtesy BPL.)

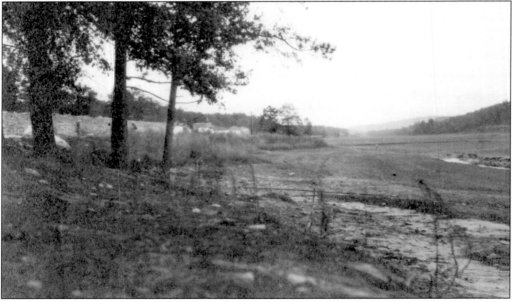

Flooding, the worst of which was in 1923 and 1935, often caused the dam to break and thus dry out the lakebed. This view looking east from today's intersection of Lakeshore Drive and Greensprings Highway shows how Shades Creek wound its way through the valley. This land is where the Ku Klux Klan had a famous rally in 1923, when more than 25,000 people descended upon the dry lakebed. (Courtesy BPL.)

Ellis Oglesby and his cousin Ezra Stacks traveled along the streetcar line to Edgewood Lake, pausing on the way to take photographs. At right, Stacks, whose mother was a Morris, stands atop the dam, defying the order to "Keep off." Below, Oglesby pops up under the tracks for a photograph near the intersection of Broadway Street and Morris Avenue. (Both, courtesy WC.)

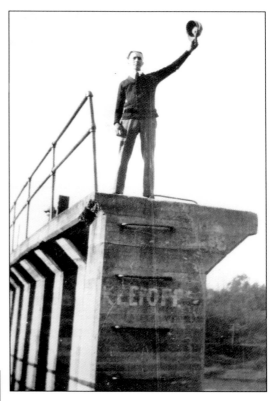

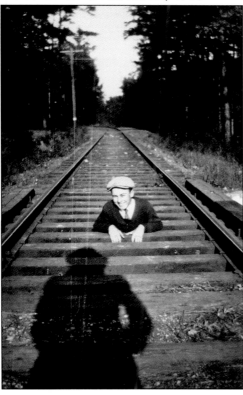

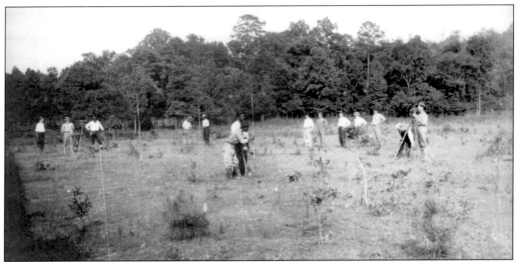

Workers survey land near Kite Hill in Grove Park, which is now part of the Edgewood neighborhood. Although the land was surveyed in the 1910s, it took a few years for people to begin building houses in that area. (Photograph by Bert G. Covell, courtesy the Griffin family.)

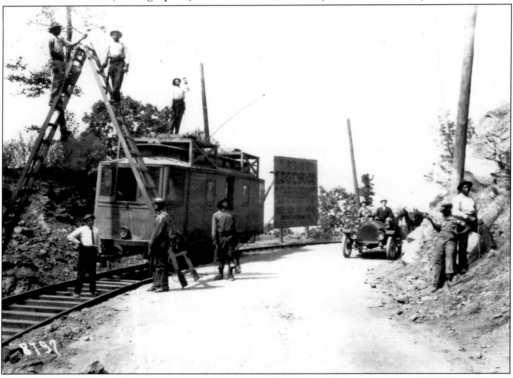

Workers install the trolley wire for the Birmingham Edgewood Electric Railway (BEER) at the top of Red Mountain. The sign in the background is an advertisement for lots for sale in Edgewood. The trolley provided transportation to and from Birmingham and was critical in luring new residents to move "over the mountain" to Edgewood. (Photograph by Bert G. Covell, courtesy the Griffin family.)

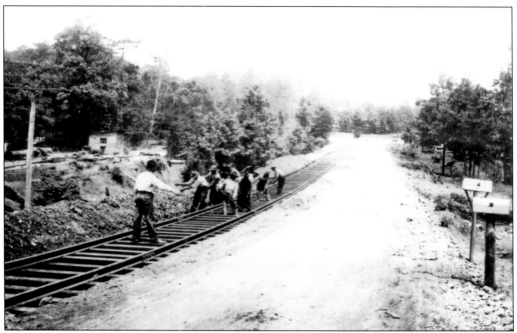

Above, workers install the trolley wire along Eighteenth Street, next to the current location of the Jefferson County Board of Education. Traveling south on Eighteenth Street, the tracks would cut down old Central Avenue to the southwest and continue through Rosedale (below). After winding through the neighborhood, the tracks headed west down Manhattan Street before turning south on Evergreen. After a quick turn west on Oxmoor Road, the tracks continued down Broadway Street, eventually reaching Edgewood Lake. The only visible remnants of the tracks today are at the intersection of Manhattan Street and Parkridge Drive. (Both, photograph by Bert G. Covell, courtesy the Griffin family.)

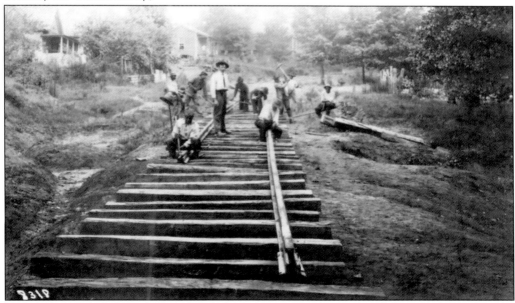

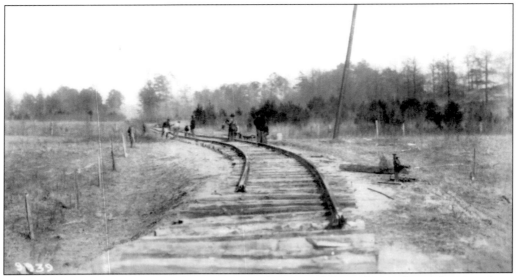

Manhattan Street, which parallels Oxmoor Road, is one of the widest and straightest roads in Homewood. After the trolley came through Rosedale, it traveled the length of Manhattan, behind present-day Homewood Park, Trinity United Methodist Church, and Dawson Memorial Baptist Church. (Photograph by Bert G. Covell, courtesy the Griffin family.)

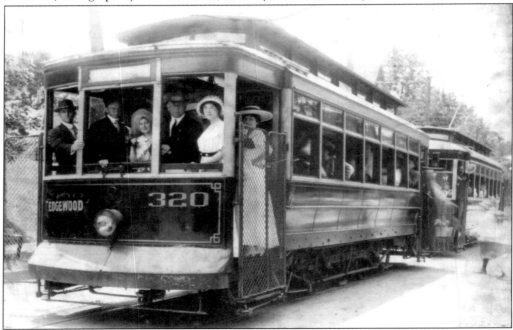

In June 1911, Stephen Smith and Troupe Brazelton planned a huge event to celebrate the inaugural trip of the Edgewood Electric Railway's first car. The route took them from the Highland Park Club, up and over Red Mountain, and down Eighteenth Street, until it curved to Central Avenue. Then, the car headed west down Manhattan Street before winding its way to Broadway Street, where the line originally ended near Shades Road. (Photograph by Bert G. Covell, courtesy the Griffin family.)

At the terminus of the line at Shades Road, Martha Dabney is pictured driving the silver spike to mark the completion of the Edgewood streetcar line. Mayor Culpepper Exum of Birmingham (to Dabney's left, wearing hat) looks on. (Photograph by Bert G. Covell, courtesy the Griffin family.)

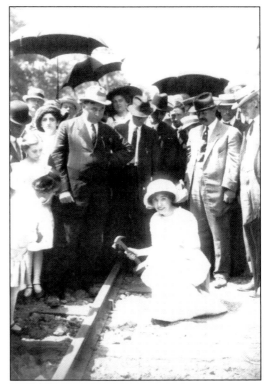

Bert G. Covell, a Birmingham photographer, was hired to capture the progress of the development of not only Edgewood, but also of the Birmingham Edgewood Electric Railway. Through the efforts of John Schor, Mayor Robert G. Waldrop, and Herbert Griffin, these amazing images have survived. (Photograph by Bert G. Covell, courtesy the Griffin family.)

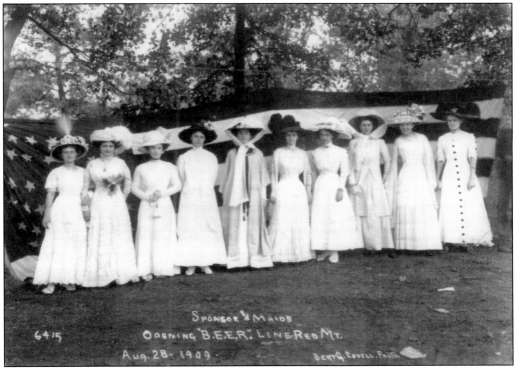

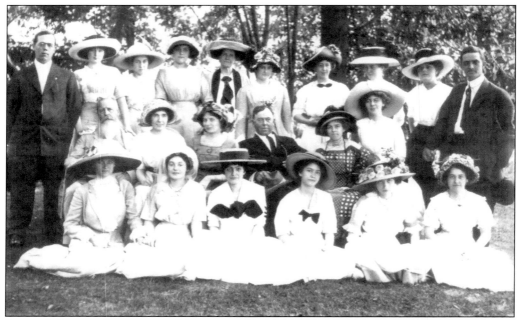

Pictured above at the opening of the streetcar line are, from left to right, (first row) Dorothy Orr Warren (Mrs. William T.), Emee McCrossin, Bessie McCrossin Hill (Mrs. Thomas J.), Serena Kirkpatrick Randolph (Mrs. Theodore F.), Marjorie Weatherly Cabiness (Mrs. Edward), and Norma Hood Lester (Mrs. B.S.); (second row) James Bowron, Martha Dabney Toulman (Mrs. Priestley Sr.), unidentified, Culpepper Exum, Nina Hood Brazelton (Mrs. Troop), and Edith Bowron Davis; (third row) Stephen Smith, Mabel Wheelock Gray (Mrs. Vernon), Bessie Mae Thompson Weller (Mrs. William), Helen Eustis Lucas, Mrs. James Bowron, Virginia Meams Nesbit (Mrs. Valentine), Fanny Dunn Baldwin (Mrs. M.M.), Isabell Caldwell Marks (Mrs. Charles), Margaret Latady Walker (Mrs. Joseph P.), and Troupe Brazelton. Several key people were invited to speak at the ceremonies pictured below. (Both, photograph by Bert G. Covell, courtesy the Griffin family.)

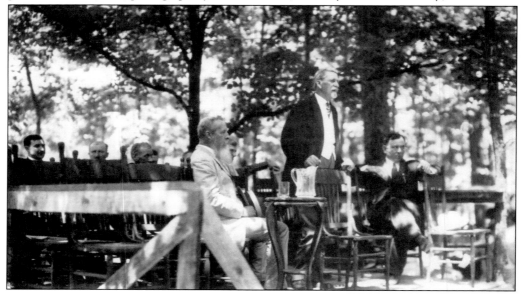

Two

THE CREATION OF A CITY "OVER THE MOUNTAIN"

The headline of the January 20, 1928, trial copy of the *Shades Valley Times* reads, "Homewood's $50,000.00 City Hall Ready To Be Occupied." The formal opening of city hall at Homewood, Alabama, was another step in the rapid growth of the new city of Homewood, which consisted of the Rosedale, Edgewood, and Grove Park neighborhoods. (Photograph by Pierce Graves, courtesy WC.)

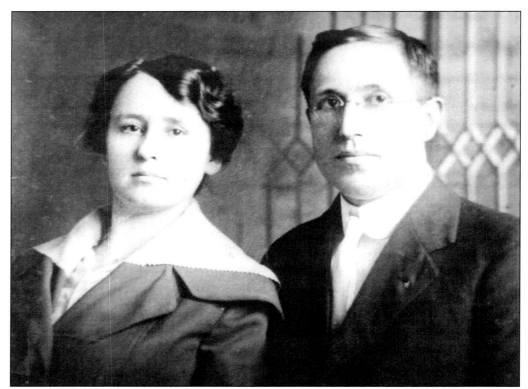

Dr. John Turpin Callaway and his wife, Francis Nora "Frannie" Haggard, were two of the most influential people in the early days of Edgewood. He was the first Master Mason of the Shades Valley Lodge No. 829, which met above his drugstore, Edgewood Drug, until 1955. When Edgewood was established as a town in 1920, he was an early mayor. While attending a service at Edgewood Community Church, Dr. Callaway mentioned to Francis that he would gladly give more money to the collection had it been for a Baptist church. Soon after, Mrs. Callaway began recruiting other Baptists in the valley to organize a church. (Above, courtesy Dawson Memorial Baptist Church; below, courtesy BPL.)

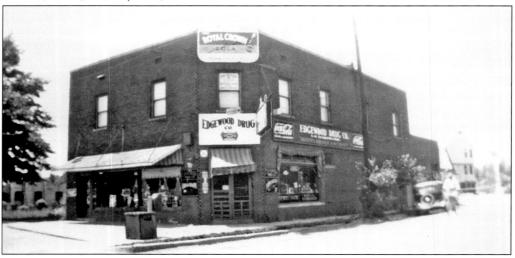

In 1920, Stephen Smith sold his home to John A. Coker, who worked for the Birmingham Paper Company. Shown above are, from left to right, (top row) Hannah Coker and Mrs. and Mr. John A. Coker; (bottom row) Walton, Sarah, and John Coker Jr. In 1925, led by Francis Callaway, the Baptist Woman's Band of Edgewood held a meeting at the Coker home for the purpose of organizing Edgewood Baptist Church. Shown below, the Coker house would continue to serve the Edgewood community for several decades, but in a very different way. Dr. John W. Simpson founded the Charlanne School after World War II to teach and train children with cerebral palsy. By 1950, the Alabama State Board of Education fully accredited Charlanne's education program. After the Charlanne School merged with the Spastic Aid Program with Jefferson County in 1955, the property was sold for business purposes and a Colonial Stores grocery was built. Dawson Memorial Baptist Church later purchased the property and first built a recreation center and now uses the property for a parking deck. (Both, courtesy Dawson Memorial Baptist Church.)

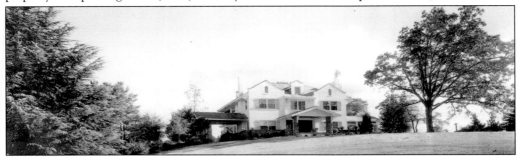

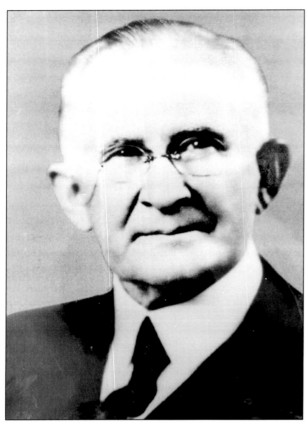

Lemuel Orah Dawson (left) was born on April 24, 1865, in Chambers County, Alabama. He attended Howard College, where he received a bachelor of arts degree in 1886—and was awarded a doctor of divinity degree by his alma mater in 1897. Dr. Dawson retired as pastor of First Baptist Church, Tuscaloosa, in 1924 to take a position at Howard College. On April 16, 1925, Dr. Dawson led a meeting with the charter members of Edgewood Baptist Church, and the first services were held in the Fieldstone Building (below) on Sunday, December 6, 1925. (Both, courtesy Dawson Memorial Baptist Church.)

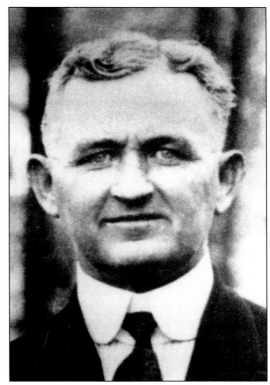

Trinity Methodist Church began as "The Little Church on the Corner" of Avenue F and Thirtieth Street in Southside around 1890. In 1909, the church relocated to Lower Highland Avenue (now Clairmont Avenue) and remained there until 1926. Much like in the development of Edgewood Baptist Church, women—specifically Sarah Weems and Mary G. Douglas—led a group that dreamed of bringing a church to Shades Valley. Trinity relocated to the 1400 block of Oxmoor Road (below), and Robert Enoch Tyler (right) was the pastor there until 1928. (Both, courtesy Trinity United Methodist Church.)

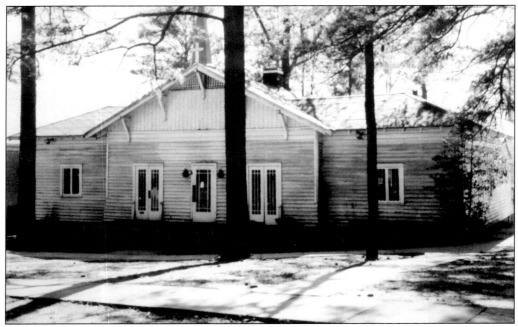

In the spring of 1928, a group of women who had moved to Homewood and were members of other Birmingham Episcopal churches began meeting. Bishop William G. McDowell led them in weekly Lenten services. In July of that year, with financial assistance from the Cathedral Church of the Advent and St. Mary's-on-the-Highland, the first Episcopal parish south of Jones Valley in Jefferson County was established in a room above the Edgewood Drug Store at the corner of Oxmoor Road and Broadway Street in Homewood. This recreational hall building was one of the few structures constructed during World War II. (Courtesy WC.)

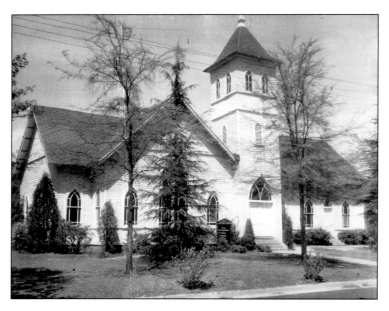

Edgewood Presbyterian Church briefly changed its name to Edgewood Community Church, a reflection of the diversity of denominations that attended there. However, after the creation of Edgewood Baptist (Dawson), Trinity United Methodist, and All Saints' Episcopal, Edgewood reverted to its Presbyterian roots. (Photograph by Pierce Graves, courtesy WC.)

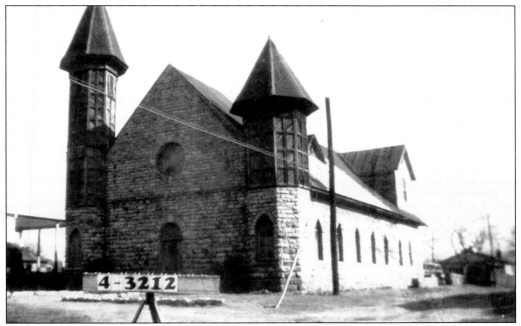

Union Baptist Church was formed on March 14, 1914, when First Baptist Church (formerly Walnut Street Baptist, organized in 1887 by Rev. J.W. White) joined with Healing Springs Baptist Church (organized in 1887 by Charles Lewis of Anniston). The two men responsible for the merger were Rev. King Noble Willis of First Baptist and Rev. J.P. Grier of Healing Springs. Ira McKinney was the first pastor of Union Baptist Church. (Courtesy BPL.)

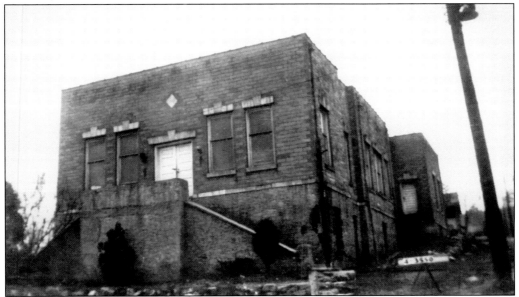

In 1926, Rev. T.B. Davis, a former pastor at Union Baptist Church, left Union and began another church. It held meetings in the John H. Jones Mercantile store until property was purchased. King Noble Willis, along with his son-in-law Eddie Brown Edgerton, built Friendship Baptist at its present location. (Courtesy BPL.)

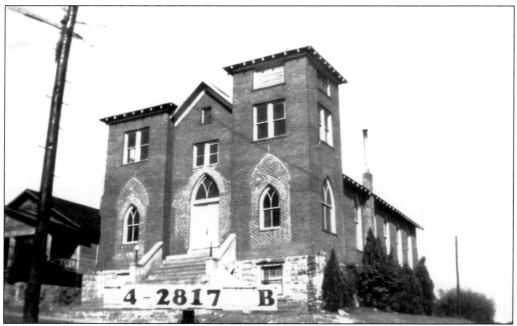

Bethel AME began under the leadership of S.T. Grove. The building where the congregation met was destroyed by fire. In 1913, a brick building was erected under the leadership of Rev. R. Gray. This structure was destroyed by fire in 1946, and a new church was completed and members worshipped together on Easter Sunday 1957. (Courtesy BPL.)

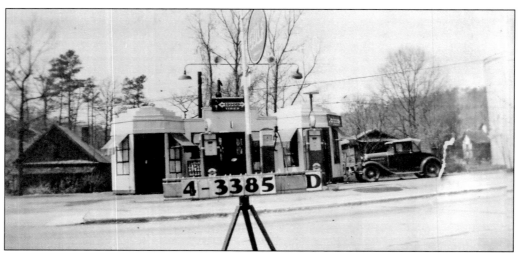

As the use of automobiles became more prevalent throughout the 1920s and 1930s, a high demand for service stations was created. One of the early stations in Rosedale is pictured here, on the west side of Eighteenth Street, where the Vulcan Restaurant was eventually built. (Courtesy BPL.)

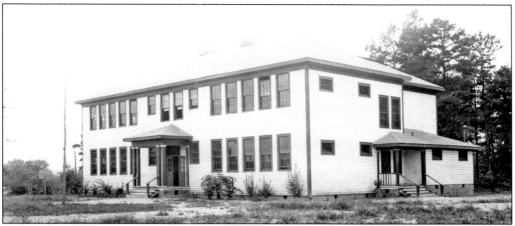

Bishop Martiene Montgomery was brought to Rosedale by his elder brother, Edward Perkins Montgomery, in the early 1900s. E.P. Montgomery saw great potential in his brother, so he took him to the Jefferson County Board of Education to have him take a test to get placed for a job. Before long, B.M. Montgomery, while only a teenager, had begun a school for the black children in Rosedale. They met in this building until it was destroyed by fire in the late 1930s. (Courtesy Jefferson County Board of Education.)

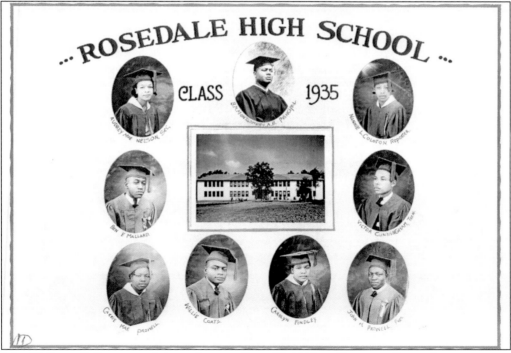

John H. Prowell (bottom right) was born on June 28, 1915, in Bessemer. Since there was not a school for blacks, he walked 10 miles a day to attend 10th grade at Miles College. Once B.M. Montgomery procured a bus for Rosedale High School, Prowell was able to attend, and he graduated in 1935. While working his way through college, he was drafted by the Army and was a first lieutenant by 1944. While serving in Italy, he was reported as MIA on May 24, 1944. (Courtesy Edward Perkins Montgomery Jr.)

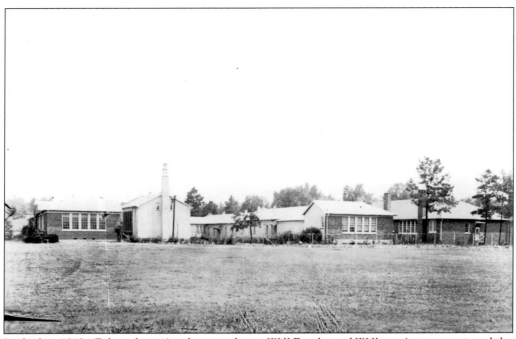

In the late 1910s, Zelosophian Academy graduates Will Franke and William Acton convinced the Jefferson County Board of Education of the need of a school south of Birmingham. A three-mill tax was proposed in order to raise funds for a school, and Shades Cahaba High School opened in 1920. Shades Cahaba served a wide geographical region, stretching from the Cahaba River north to the Birmingham city limits, and from Shannon east to the St. Clair County line. Above, the courtyard at center was just beyond right field in relation to the baseball field. According to Raleigh B. Kent, it took a great hitter to get a ball to the courtyard. Shown below is the original front of Shades Cahaba School. (Both, courtesy Jefferson County Board of Education.)

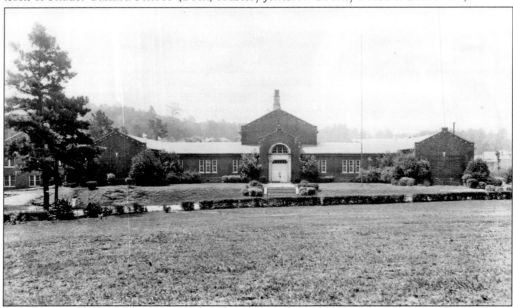

After earning his bachelor's degree at the University of Alabama, James M. Ward moved to New York, where he earned his master's degree from Columbia University. He moved back to Alabama and became the principal of Shades Cahaba School at the young age of 23. One of the early duties that Ward faced as principal was to erect a small fence around the grounds at Shades Cahaba to prevent wandering cattle from destroying the shrubbery around the school. Professor Ward served Shades Cahaba as principal until 1943. His wife, Norvia, also taught at the school; together, they were two of the founding members of Edgewood Baptist Church (later Dawson Memorial Baptist Church). (Courtesy Dawson Memorial Baptist Church.)

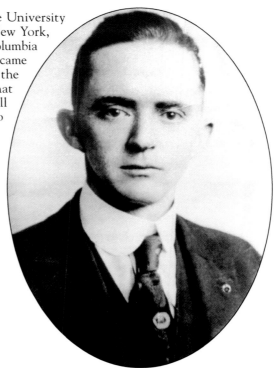

The land for Edgewood Elementary School, which at the time was a muddy field with no road leading to it, was purchased from H.M. Byars in the early 1920s. Residents were upset when they found out the county only wanted to build a two-room school. After much debate, a four-room school was built. It opened in September 1926. (Courtesy Jefferson County Board of Education.)

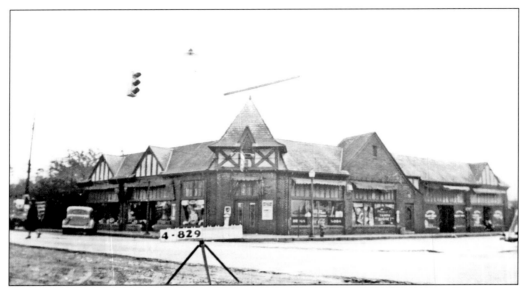

Duddy's Pharmacy, located on the southeast corner of Oxmoor Road and Broadway Street, was a popular spot in Edgewood, known mostly for its soda fountain. This photograph shows the same view as that seen from the Smith home (see page 35). (Courtesy BPL.)

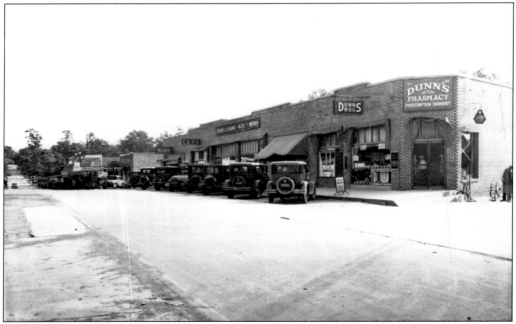

Druggist Ernest Dunn was from Linden, Alabama. He moved his family to 320 LaPrado Place in Hollywood around 1930 and opened Dunn's Pharmacy around the same time on the corner of Eighteenth Street and Central Avenue. This early photograph of downtown Homewood shows the corner of Eighteenth Street and Twenty-Eighth Avenue South. To the left in this view looking south on Eighteenth Street, Dunn's is located on the corner, followed by the Great Atlantic & Pacific Tea Co. grocery store, a café, S.G. Shaia's, S.G. Shaia's family garden, Piggly Wiggly, a gas station, and the Homewood Theatre. (Courtesy Jimmy Wilson.)

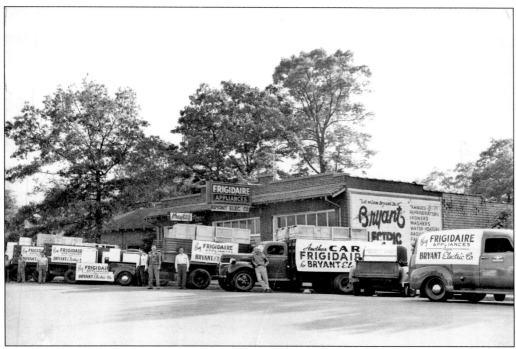

In August 1927, Lem Bryant opened Bryant Electric Company at 2852 South Twenty-Eighth Street, specializing in electrical contracting. With so much building going on in the Homewood area, business was booming. At one time, Bryant employed 41 people, had a fleet of trucks, and added appliances to his inventory. His catchphrases were "Let Lem do it!" and "Large enough to serve you, small enough to know you." Bryant Electric did all kinds of work—from installing an alarm system in the bank and installing the fire alarm in the old city hall building to wiring the lights at the Shades Cahaba football field. (Courtesy WC.)

Charles Rice, who had been involved with the Birmingham & Motor Country Club, was asked by residents of Grove Park to assist in developing their own city government. Rice saw an opportunity to unite several small townships and create one larger city in Shades Valley. The Edgewood Town Council called a special meeting and overwhelmingly voted to merge Rosedale, Edgewood, and Grove Park and call the new city Homewood. Rice was elected mayor. On February 11, 1927, Homewood was officially recognized by the State of Alabama. (Courtesy Joyce Rice Norton.)

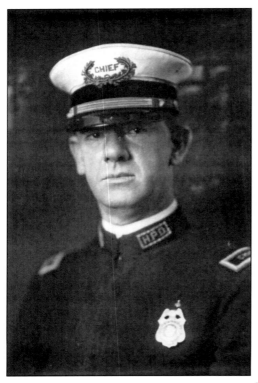

At left is Vernon F. "Red" Cunningham, who grew up on the northwest corner of Twenty-Eighth Avenue South and Nineteenth Street South, was Homewood's first police chief, earning $250 a month. Prior to Homewood's incorporation, he served in the Birmingham Police Department. In 1927, Homewood had a total of five police officers, including E.L. "Bud" Scott and Capt. W.F. Patterson. Among the early police chiefs in Homewood was Bud Scott, pictured below in front of the old Hollywood Town Hall on Oxmoor Road. Scott suffered a motorcycle accident along Eighteenth Street that forced him into retirement. (Left, courtesy Ray Cunningham; below, courtesy Homewood Police Department.)

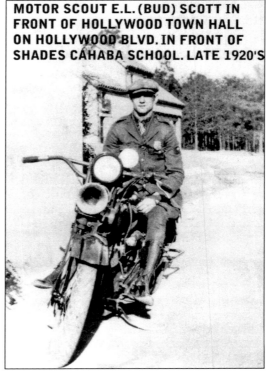

MOTOR SCOUT E.L. (BUD) SCOTT IN FRONT OF HOLLYWOOD TOWN HALL ON HOLLYWOOD BLVD. IN FRONT OF SHADES CAHABA SCHOOL. LATE 1920'S

Long before Hollywood became one of the most beautiful neighborhoods in Shades Valley, it was a vast wilderness. This log cabin, which was later renovated, is at 536 Manchester Lane. It was one of the first structures in what became Hollywood. The owners had stables and boarded horses. (Courtesy BPL.)

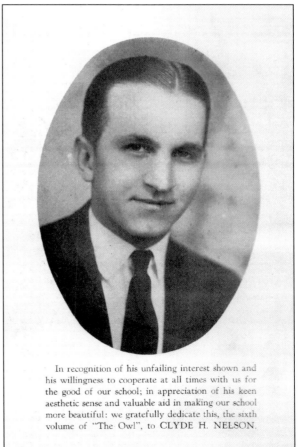

In recognition of his unfailing interest shown and his willingness to cooperate at all times with us for the good of our school; in appreciation of his keen aesthetic sense and valuable aid in making our school more beautiful: we gratefully dedicate this, the sixth volume of "The Owl", to CLYDE H. NELSON.

Much like Smith and Brazelton, Clyde Hardy Nelson had a vision for a community in Shades Valley. Nelson envisioned his neighborhood having a uniform architectural design, which would distinguish the community from others. He chose the Spanish Mission style, and named his development "Hollywood." Today, the Hollywood Homes Tour provides architectural tours of the older Hollywood residences. (Courtesy Shades Cahaba School.)

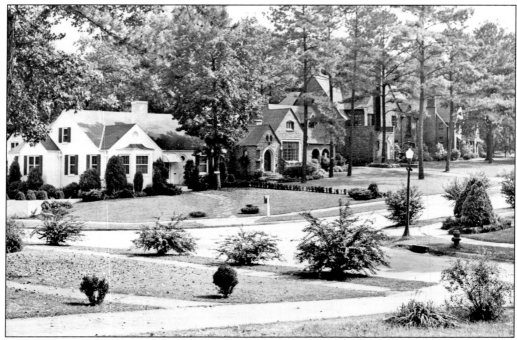

Shown above are houses along English Circle at the intersection of La Prado Place. Although Nelson had the intention to build all homes in the Spanish Mission style, not all homes were constructed that way. Pierce Graves exemplified the future US Postal Service motto, "Neither snow, nor rain, nor heat, nor gloom of night stays these couriers from the swift completion of their appointed rounds." He traveled to Hollywood in the snow to take below photograph of the intersection of Hampton and Windsor Drives. (Both, photograph by Pierce Graves, courtesy WC.)

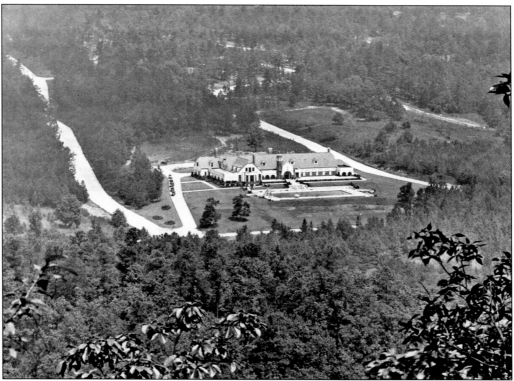

The Hollywood Country Club was a Spanish Mission clubhouse built on Shades Creek Parkway, where the Courtyard by Marriott stands today. The club had a pool, as well as a summer bus line that ran from the pool to Dunn's Pharmacy and to the corner of Broadway Street and Roseland Drive. The Hollywood Country Club exchanged hands several times and became a well-known music venue. It was called Brothers Music Hall in the 1970s before it became Hollywood Underground in the 1980s. Hotel, a local band, was everyone's favorite show, but others who played at the old country club included Alabama, the Police, Billy Idol, Bob Marley, and Hank Williams Jr. (Above, courtesy BPL; below, courtesy Jimmy Wilson.)

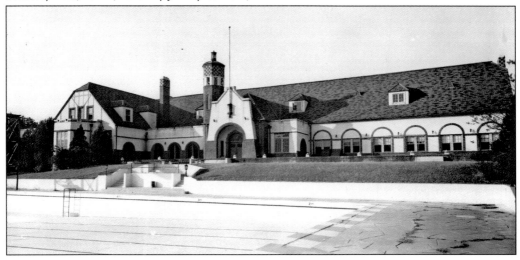

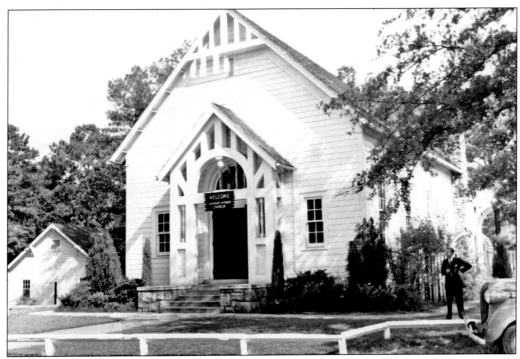

Union Hill Methodist Church became known as Canterbury Methodist Church. It sat exactly where Highway 280 separates Homewood and Mountain Brook. The Union Hill Cemetery still exists, but the church is now located in Mountain Brook. (Courtesy Jane Dorn.)

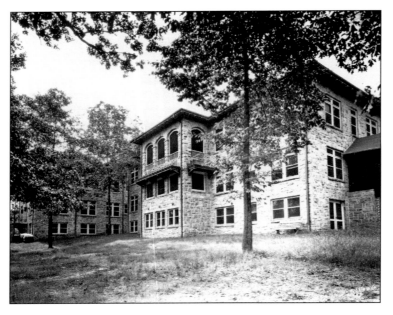

The Jefferson County Tuberculosis Sanatorium is pictured in the 1930s. Additions were made to the sanatorium during Roosevelt's New Deal. During World War II, German prisoners of war held at the former County Prison Camp No. 5 on Lakeshore Drive served as janitors, cooks, and orderlies. The building is now used as Lakeshore Rehabilitation Hospital. (Courtesy BPL.)

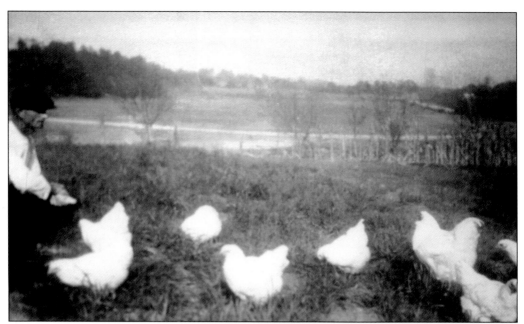

The Hillcrest Country Club was built in 1910. A nine-hole golf course sat where the Palisades Shopping Center is today. Above, in a view looking out over the first two fairways, S.A. Oglesby feeds his chickens. Pictured at right, Fred E. Lawville was the first golf pro. He married Wilma Oglesby. This photograph was taken in front of his father-in-law's house on Oxmoor Road. The property was eventually bought by the Shriners, who used it until the 1980s, when they moved to Irondale. (Both, courtesy WC.)

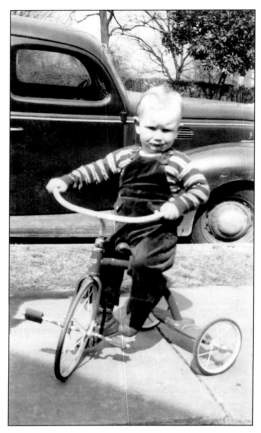

Truman Parrott (left), who grew up across the street from the Cunningham house and next door to Pierce Graves, poses on his tricycle. The Parrotts were one of the last families to vacate downtown Homewood after the postwar commercial boom. Truman attended Howard College and taught history at Homewood Junior High School for over 30 years. His grandfather John B. Parrott (below) was one of the conductors in town. (Left, photograph by Pierce Graves, courtesy Truman Parrott; below, photograph by Pierce Graves, courtesy WC.)

Pierce Graves, a graduate of Birmingham Southern College, was a local postman and an exceptional professional photographer. He did work for the *Shades Valley Sun* and was often commissioned by families to take portraits. Above, he shows off his vehicle, with the Cunningham house at Nineteenth Street in the background. Below, Graves's wife, Virginia, is seen next to their home on Twenty-Eighth Avenue South, tending to her victory garden. Many residents cultivated these gardens during World War II. Virginia was also an accomplished organist and taught lessons. (Both, photograph by Pierce Graves, courtesy WC.)

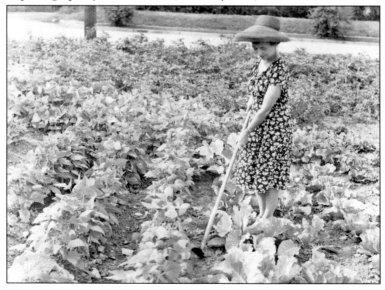

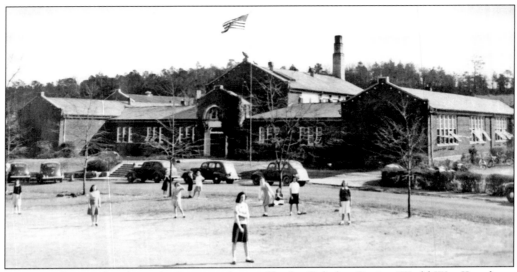

Above, girls attend a physical education class at Shades Cahaba. During World War II, upkeep at the schools fell on the citizens, as seen below. Young men were off defending their country, and many women were called upon to help. On October 2, 1944, Juanita Weaver, chairperson of the Shades Cahaba PTA, explained that they did not have enough money to buy materials for a sidewalk and pay for the labor. So, she asked residents to gather picks, shovels, and hoes to complete the work. Weaver promised refreshments, but not until the work was done. (Both, courtesy Shades Cahaba School.)

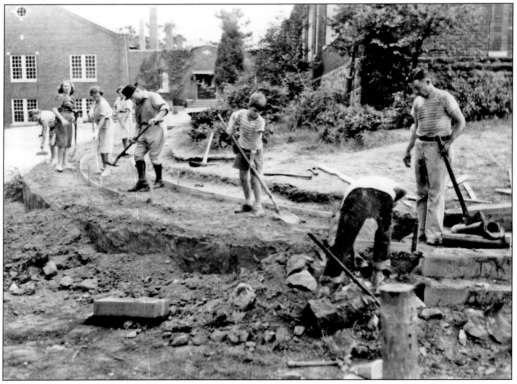

When Herb Griffin was in the eighth grade, his little brother's terrier, Flossie, wandered away from the family house on Sterrett Avenue. Herb borrowed a bicycle and began to look for her. He spotted Flossie near the intersection of Evergreen Avenue and Manhattan Street (above). As he tried to corral her, the bicycle got stuck in the streetcar tracks. While trying to retrieve both, he did not realize that a streetcar was approaching from the east. He tried to get to the other side of the trestle, but his foot got caught. He lay down in the center of the tracks, but the streetcar mangled his leg where it was caught. Herb rode the streetcar around the turn to Edgewood Drug, where he met an ambulance that had been called by Peggy Burline. Herb's story became famous, and the *Birmingham News* even came to the hospital for a photo shoot (below). (Both, courtesy the Griffin family.)

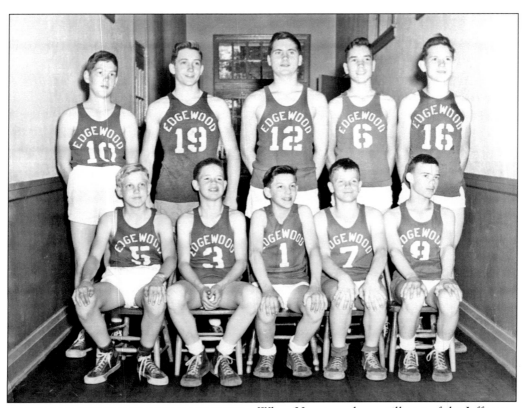

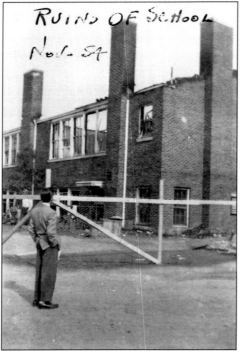

When Homewood was still part of the Jefferson County School System, students attended Edgewood through the eighth grade. Members of this Edgewood basketball team are, from left to right, (first row) Richard Hauenstein, David Cauthen, Angie Labert, Taylor Wingo, and Scott Corley; (second row) Jackie Selby, Andy Duncan, Bob Ward, Roy Costner, and Buddy Acton. (Courtesy Charlie Lane.)

In the fall of 1953, disaster stuck Edgewood Elementary School. During the night, fire broke out and burned most of the school. The community pitched in to help the fire department in several ways. Schoolboys helped lay water hoses for the firemen, and residents ran into the building to retrieve records. (Courtesy the Griffin family.)

Oren Prentice "Piggy" Mitchel not only coached the major sports at Shades Cahaba, but also took time to help with the local YMCA baseball team. Shown are, from left to right, (first row) Bobby Christiansen, Jackie Kopp, Charlie Brooks, R.B. Kent, and Baker Allen; (second row) Richard Stevens, James Barnett, Fletcher Allen, Bill Mathis, Tommy Williams, and Coach Mitchell. (Courtesy Joan Kopp.)

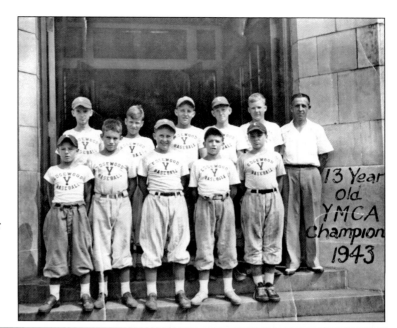

Piggy Mitchell was not the only football coach at Shades Cahaba in the 1940s. In 1948, the sixth-grade football team needed a coach, and none of the boys in the school would help. Joan Eddleman took over and had a 2-0 record as a head coach. Seen here are, from left to right, Peter Reque, Bill Hoover, Billy Moon Turner, Neil Andrews, Paul Goree, Sidney Godbee, and Eddleman. (Courtesy Joan Kopp.)

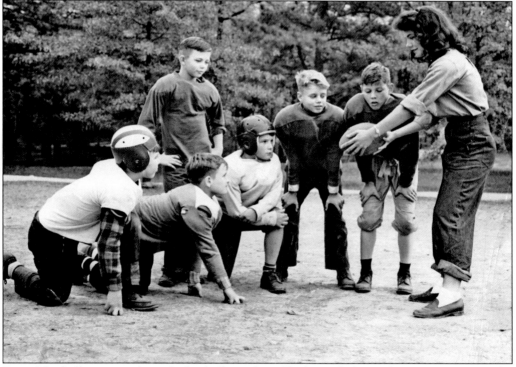

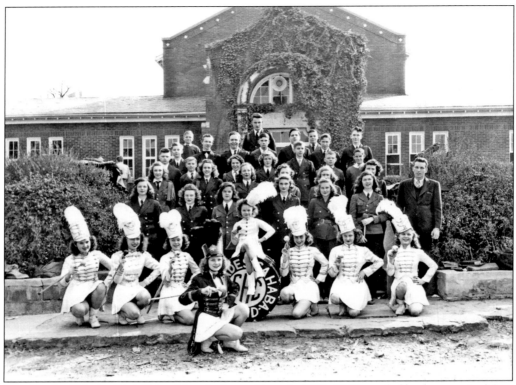

The Shades Cahaba High School band, pictured here in 1945–1946, was led by drum major Mary Louise Painter (in front). Other band members included Ray Cunningham, Don Lynch, and Bill Slimp. (Courtesy BPL.)

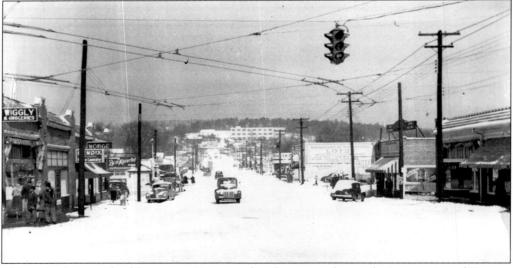

This early photograph of downtown Homewood in the snow, taken at the intersection of Twenty-Eighth Avenue South and Eighteenth Street, gives a clear view of Rosedale High School at the top of the hill. Other businesses seen are Piggly Wiggly, Bendix Laundry, Shell gas station, Firestone, and the Lotus Club. (Photograph by Pierce Graves, courtesy WC.)

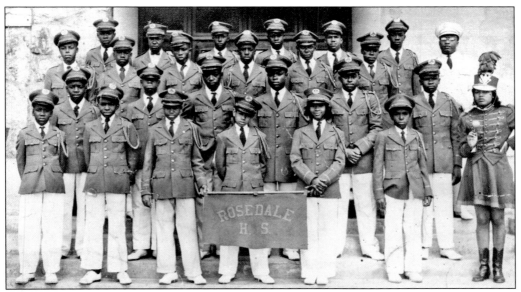

The Rosedale High School Band, pictured here in 1947, was the pride of the school. Every Friday night, the band members would march from the school to the field (where Red Mountain Expressway is today), and residents of the neighborhood would follow them to the game. Among the band members pictured are Sterling Jones Sr. (first row, fourth from left) and Fred Sheppard (second row, third from left), whose parents came to Rosedale in the early 1930s. The Sheppards are active members of Bethel AME Church. (Courtesy Edward Perkins Montgomery Jr.)

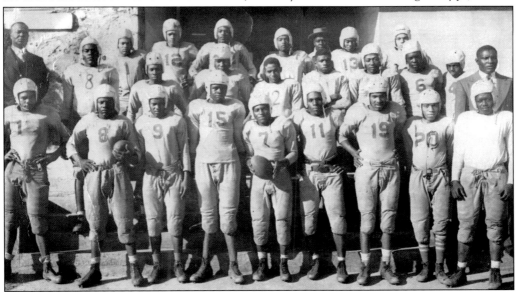

The Rosedale football team, known as "The Mighty Sons of Kong," was coached by William N. Coger (second row, far right), who was almost six feet, seven inches tall, wore a size 24 shoe, and had the biggest hands residents had ever seen. Coger, a graduate of Miles College, was one of the first faculty members hired by B.M. Montgomery (third row, far left). Coger greeted students every day by requiring them to salute the flag as they came in the school. (Courtesy Edward Perkins Montgomery Jr.)

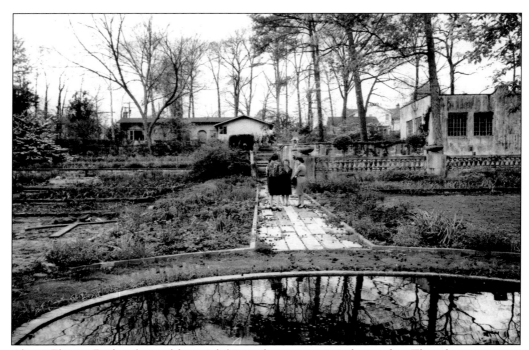

Above, Eleanor Bridges (second from right) is ready to entertain in her garden. The other women are unidentified. For many years, Bridges was the official hostess of Homewood. She even entertained F. Scott and Zelda Fitzgerald. Bridges was quite a feminist and roomed with Amelia Earhart while at the Ogontz School for Young Ladies. She studied at many colleges, including the Académie Julian in Paris, France. There, she sat on the curbs of streets and sketched horses as they traveled around the block. She and her husband, Georges, built a beautiful pink stucco house, pictured below in 1920 at the corner of Edgewood Boulevard and Roseland Drive. They even had pink stucco stables for the horses and a fireplace to keep them warm. Every May, there was a maypole dance on the lawn for children. Georges was a renowned sculptor; his most famous work in Birmingham is the *Brother Bryan* statue. The estate is now owned by Eric and Diana Hansen, who own White Flowers in downtown Homewood. (Above, courtesy Diana Hansen; below, courtesy BPL.)

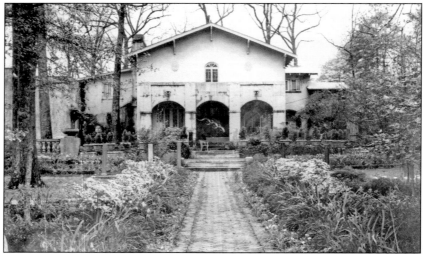

Dawson Memorial Baptist Church and Trinity United Methodist Church both sponsor large Boy Scout troops in Homewood. Here, Boy Scout Troop No. 83 is pictured in front of the Fieldstone Building of Dawson Memorial Baptist Church in 1946. J. Ivey Edwards was the pastor, and Herman Dean Jr. was the Scoutmaster. (Courtesy Charlie Lane.)

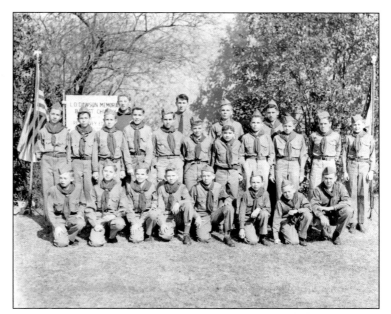

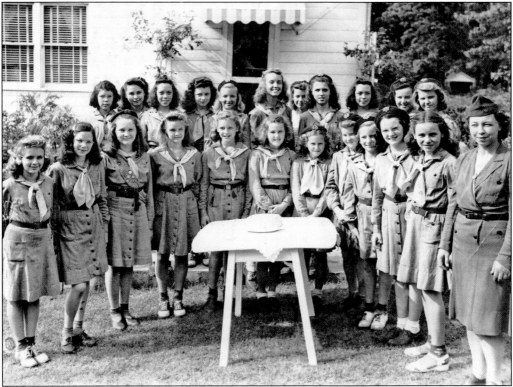

The Girl Scouts have also been very active in Homewood. Scoutmaster Elizabeth Hamner (far right) is pictured here in 1946 with Troop No. 90 in Jane Costner's backyard for a birthday party. The troop was sponsored by the Edgewood Parent Teacher Association. That year, the Scouts celebrated the second anniversary of the troop's founding. (Courtesy Ruth Yarbrough.)

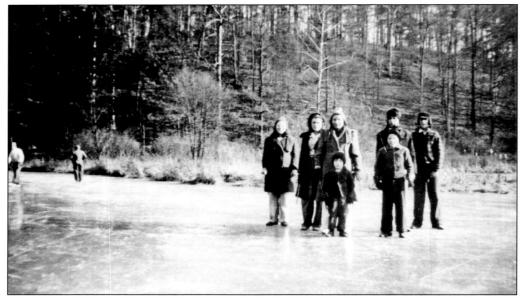

In the early 1940s, Rosedale Branch (also referred to as Blue Hole), where Griffin Brook pools near the intersection of Saulter Road and Broadway Street, was completely frozen two different times. Many residents took advantage of the conditions, bringing their skates out of storage and skating, or just walking, out on the ice and posing for photographs, such as the Dawson family did here. (Photograph by John W. Dawson, courtesy WC.)

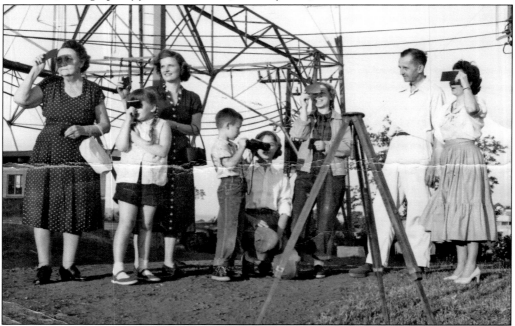

Jack Hamner (second from right), founder of the Shades Valley Astronomy Club, is seen here on top of Red Mountain, using old negatives to look at an eclipse near the WBRC-TV (Bell Radio Company) buildings. Also shown are his daughter Ruth (fifth from left) and his wife, Elizabeth (sixth from left). (Photograph by Pierce Graves, courtesy Ruth Yarbrough.)

Leah Rawls, pictured here on her pony, used to ride from her house, near the Edgewood Lake Dam, along Bald Ridge and down to the stables that were run by a Mrs. Merritt, near the old County Prison Camp No. 5 at the intersection of Old Highway 31 and Lakeshore Drive. Rawls went on to be a professor at Samford University and Auburn University and wrote several books on the history of Birmingham. (Courtesy Dr. Leah Rawls Atkins.)

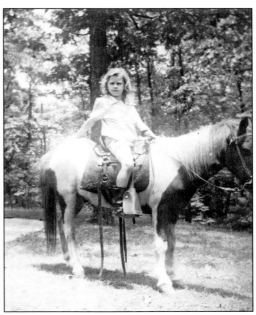

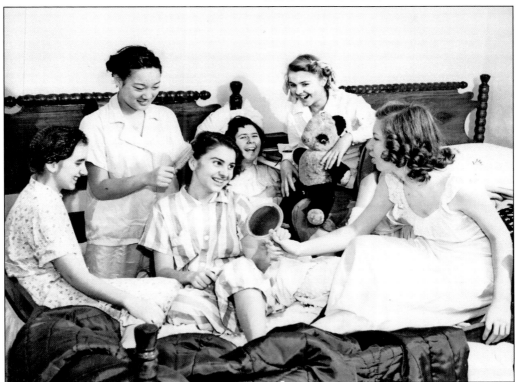

These girls enjoy a slumber party in the late 1940s. They are, from left to right, Patricia McCarter, Jo Ann Loo, Ruth Jane Smith, Shirley Ogletree, Ruth Hamner, and Sara Jo Cooke. Loo's family, owners of the Joy Young Restaurant in downtown Birmingham, were the first Chinese family to move into Homewood. (Courtesy Dr. Leah Rawls Atkins.)

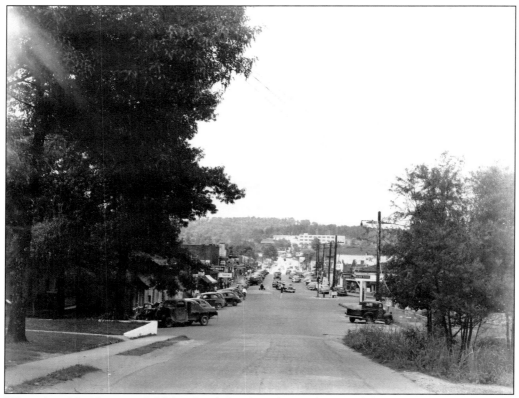

When Ann Hinkle was a child, her family lived in a house that stood about where Savages Bakery is today. There was a "frog pond" behind her house, and she accidentally fell in one day. O.A. Lindsey, who was the postmaster in the early 1930s, pulled her out. On the right is the path Ann took to Shades Cahaba Grammar School as a little girl. (Courtesy the Hallman family.)

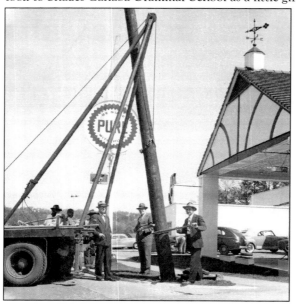

In 1949, leaders in Homewood decided that lights were needed along the highway. Pictured are, from left to right, (first row) W. Price Hightower (president, Homewood City Council) and W.C. Mathews (chairman, projects committee), and Richard Hinkle (past president of the chamber of commerce) at the installation of the first streetlight in Homewood, at the corner of Highway 31 and Oxmoor Road, in front of the filling station and the Jack O'Lantern. (Courtesy Ann Massey.)

Juanita Weaver stands outside of the Jack O'Lantern (above), near the corner of Highway 31 and Twenty-Seventh Avenue South. The Jack O'Lantern was known for its glass-top bar (below), chicken plates, steaks, and "a million yards of spaghetti for 50 cents." The restaurant was the place to host bridge parties. For entertainment, there was a jukebox, and the wife of the owner, Joe Joseph, played the piano and sang. (Both, courtesy Birmingham History Center.)

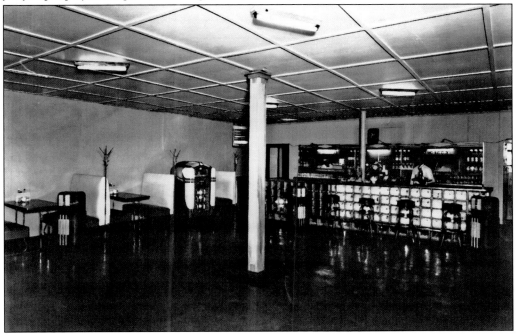

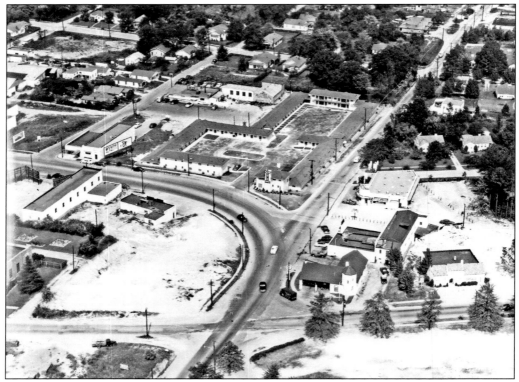

The above photograph provides reference for some of the businesses on Old Highway 31. From the crossroads, travelers would pass the Pure Oil station, the Jack O'Lantern, and Christy's on the right. Turning left on Twenty-Seventh Avenue, the Vulcan Motor Lodge was on the right and backed up to the Pig Trail Inn on Nineteenth Place South. Below, in a view looking north on Eighteenth Street, businesses include M.A. Farley Dry Goods (far right) and the Lotus Club (right of center), which is now the location of the Little Professor Bookstore. (Both, courtesy BPL.)

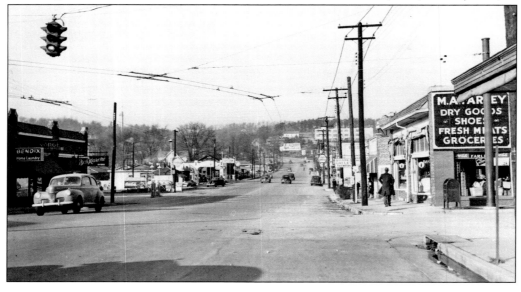

THE LOTUS

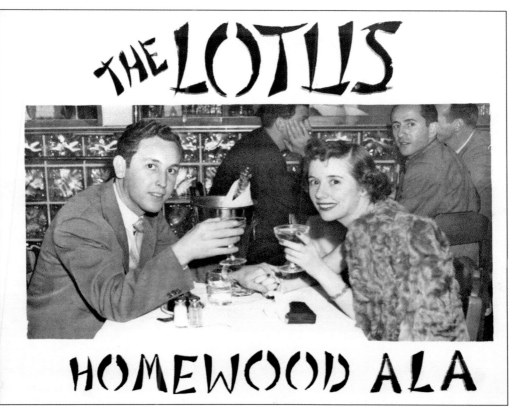

HOMEWOOD ALA

The Lotus Club was a very popular place for dinner and special occasions. Pictured above on their first date are Dave Willoughby and Beverly Durham. J.L. Shaia and his wife, like many others, had their wedding reception at the Lotus. The club provided a wide variety of entertainment, booking local magician Cliff Holman, legendary crooner Bobby Darin, and the wild rock 'n' roller Jerry Lee Lewis. Below, the large dining room on the first floor is pictured. To the far left is the bandstand. (Above, courtesy Jan Eady; below, courtesy BPL..)

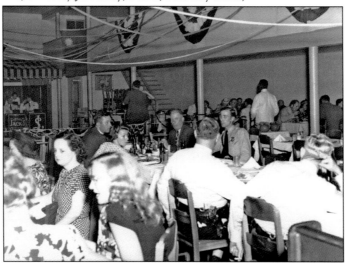

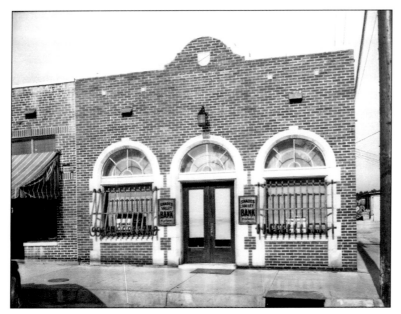

As the population in Shades Valley grew, the need for a local bank became apparent. Shades Valley Bank, which offered a staggering four percent interest on a savings account, was located on Eighteenth Street in downtown Homewood, where O'Henry's is today. (Courtesy BPL.)

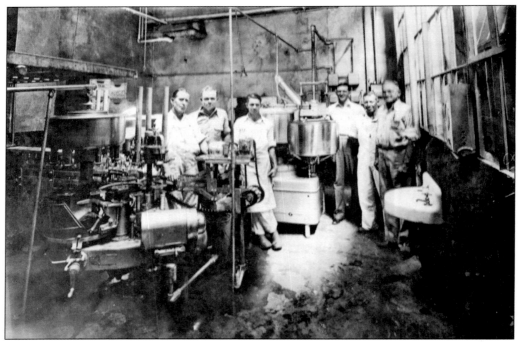

Homewood Dairy was one of the longest-running businesses in downtown Homewood. The Burrell, Jones, and Williams families owned the dairy. Known for its ice-cream parlor, it also delivered milk to homes. Sallie Jones remembers the slogan, "You can whip our cream but you can't beat our butter." Herb Griffin remembers everyone wearing white aprons that they would don at home, walk through the cow pastures wearing, but somehow manage to keep clean. (Courtesy Tom Jones.)

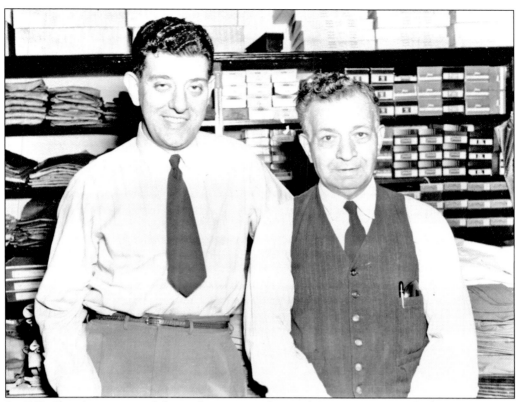

In 1955, Shaia's store moved down the street, and two of A.J.'s sons, Leo and John Lewis "J.L.," took over. The Shaias adapted to the changing demands of Homewood and began to specialize in fine men's clothing. By 1965, Shaia's was dedicated to providing the finest men's clothing in Birmingham. For 12 consecutive years, Shaia's has been on *Esquire* magazine's list of the nation's best men's retail stores. Shown above are A.J. (left) and S.G. Shaia. Pictured below are, from left to right, Leo Shaia, a Mrs. Townley, S.G. Shaia, Thelma Acton, Ruth Nation, and J.L. Shaia. (Both, courtesy the Shaia family.)

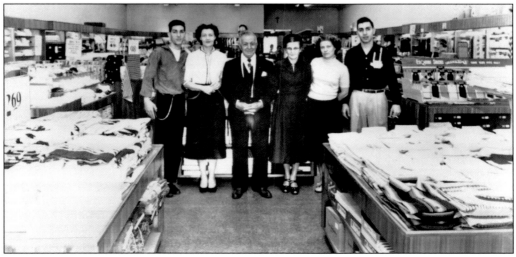

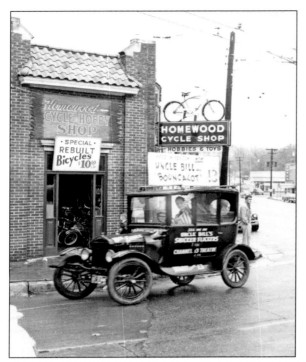

Pictured here in 1955, Homewood Toy & Hobby has been in business in downtown Homewood since 1950. Its first store was at the corner of Eighteenth Street and Twenty-Eighth Avenue South, eventually moving south on Eighteenth Street into the old Homewood Theatre in the early 1960s. Homewood Toy & Hobby began by selling lawn mowers and bikes, but, over the years, it changed and adapted to the customers of Homewood. (Both, courtesy Steven Westbrook.)

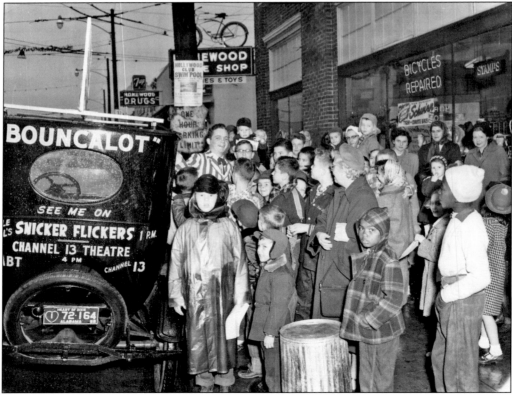

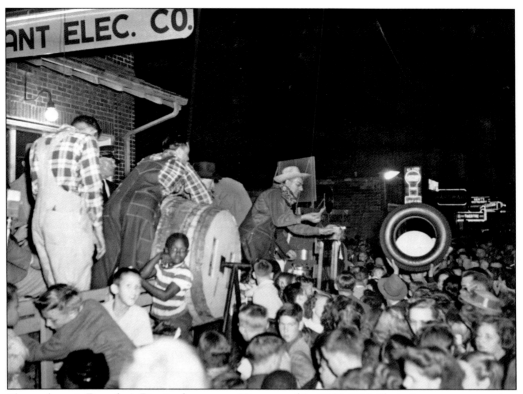

Shown here is Founder's Day in downtown Homewood in 1948. S.G. Shaia is at center, wearing a cowboy hat. Pictured under the sign in a conductor's suit is Lem Bryant. (Courtesy the Shaia family.)

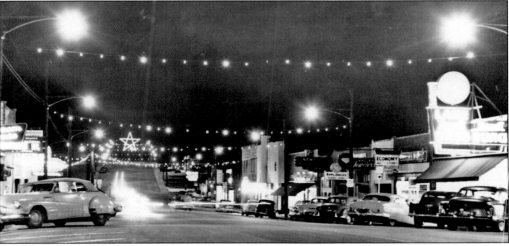

Douglass McConnell, of McConnell Sales & Engineering Corporation, made the now-famous Homewood Star sometime prior to 1951. Every year, the star is hung on the south end of Eighteenth Street, and the mayor lights the star after performances by the Homewood Middle School choir. The lighting of the star signifies the beginning of the Christmas season in Homewood. (Photograph by Pierce Graves, courtesy WC.)

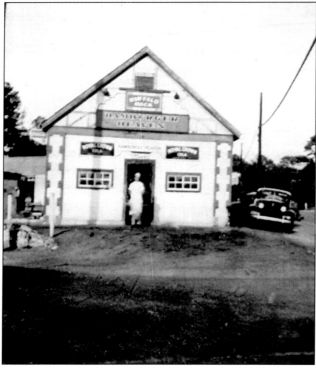

Members of Homewood's Businessmen's Association, the Shades Valley Exchange Club, the Homewood Lions, and American Legion Post No. 134 formed a committee in 1947 to develop Homewood Park (above). Under the leadership of Claude Morton, the city council passed a resolution to develop a park board. The community center and pool was completed in 1954. At left, Hamburger Heaven is seen at the corner of Oxmoor Road and Central Avenue. Joe Flemming, along with his brothers Tom and Hap, who had just returned from World War II, began Hamburger Heaven, which stood across the street from Homewood Park. (Above, courtesy Roy and Becky Morton; left, courtesy WC.)

In the above photograph, with a view looking east on Oxmoor Road where it intersects with Central Avenue, Butler's Flowers is on the left. Nabeel's, a fine Mediterranean restaurant, occupies the majority of the block now, along with Homewood Music. The Gulf gas station seen below was run by C.B. Snelling for decades. Snelling lived at the corner of Oxmoor Road and East Glenwood Drive. He kept goats, providing their milk to the local residents who had children who were lactose intolerant. (Above, courtesy BPL; below, courtesy Mike and Karen Snelling.)

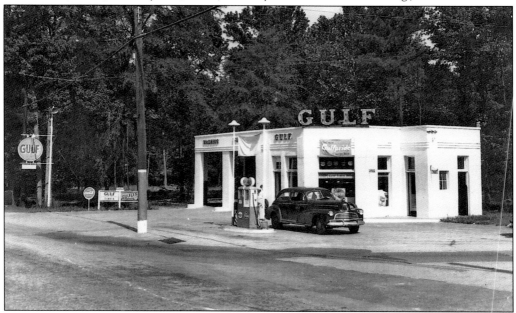

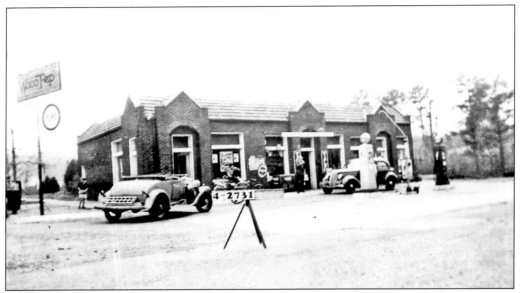

The Pure Oil station (above), located across the street from the Gulf station, stood where Applause Dancewear is today. In the 1950s, a newer station, known as Leo Edmonson's Pure Oil, was built. Edmondson was known for his big smile and glass showcase of candy. Below, the Standard Oil station, seen here on the west side of Eighteenth Street, just in front of Union Baptist Church, was one of the early service stations in Homewood. Behind the station is the western half of the Rosedale, where the streetcar descended Red Mountain before heading west down Manhattan Street. (Both, courtesy BPL.)

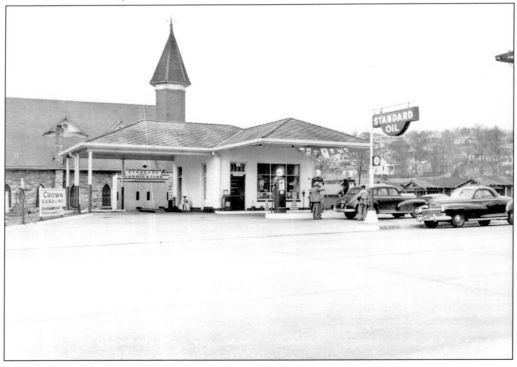

Many zoning laws were changed as Homewood continued to grow. For example, the Montgomery home was destroyed by fire in the 1950s. In order for the family to continue to utilize their property, they were required to construct a commercial building. Barbara Tubbs is seen here outside of the E.P. Montgomery store on Twenty-Sixth Avenue in Rosedale. "Mrs. Barbara," as everyone calls her, organizes the Rosedale Reunions every summer. Much of the preservation of the Rosedale community is done thanks to her. (Courtesy Edward Perkins Montgomery Jr.)

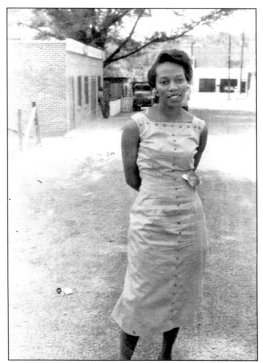

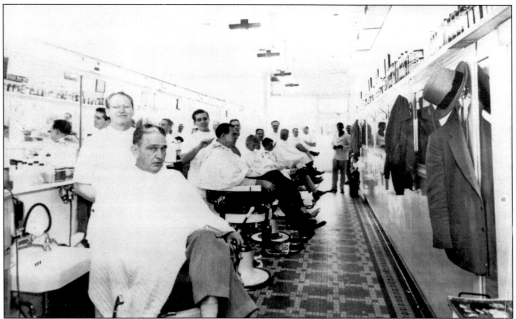

The Homewood Barber Shop, owned by Buck Horton, was formerly located on the 2800 block of Eighteenth Street, where Sam's Super Samwiches is today. The barbers pictured standing here are, from left to right, Buck Horton, Jerry Morgan, Carl Holland, Shorty Perry, George Milburn, and Johnny Tate. Dallas Hutchison Jr. (far right) shined shoes at the barbershop. (Courtesy the Morgan family.)

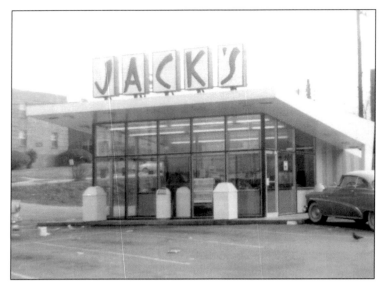

Jack Caddell ran the Pig Trail Inn in downtown Homewood for years before deciding to open up his own place, where he sold hamburgers at the price of 15¢. Jack's eventually franchised and has become one of the most successful hamburger chains in Alabama. The corporate office of Jack's Hamburgers is located in west Homewood. (Courtesy WC.)

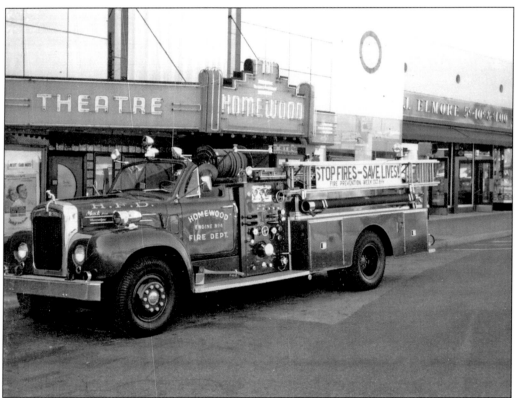

The Homewood Theatre was a mainstay in downtown Homewood, going back to the 1930s. Although the original building was torn down, the Homewood Theatre thrived until the early 1960s. Pictured here with a brand-new 1959 Mack fire truck in front, the theater was commonly referred to as "The Show." There was only one theater inside, and many residents spent their Saturday afternoons there. (Courtesy Homewood Fire Department.)

The Montgomery family saw a need for the children of Rosedale to have a safe place to hang out. In 1948, Charlie and Henry Montgomery built the Montgomery Building on the west side of Eighteenth Street. The first floor housed a beauty parlor and a café. The upstairs was intended to house a movie theater, but it was too close to the Homewood Theatre to attain rights to show movies. (Courtesy BPL.)

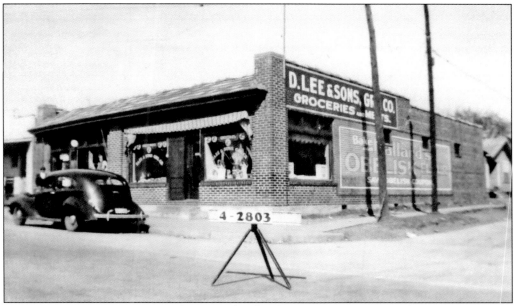

D. Lee & Sons Grocery sat on the east side of Eighteenth Street, near today's intersection of Highway 280 and Eighteenth Street. As the traffic on Eighteenth Street increased, the city continued to widen the road, eventually leading to the destruction of this building. The store moved across the street, to the north of the Montgomery Building. (Courtesy BPL.)

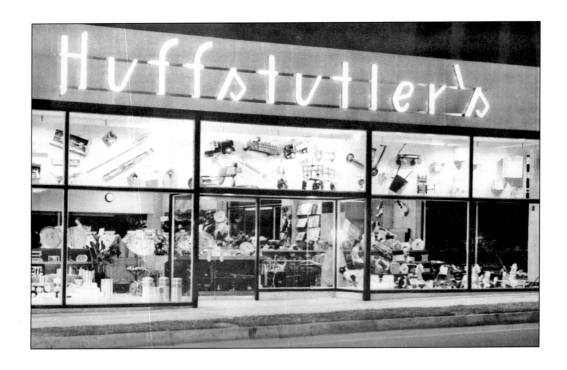

T.W. Huffstutler Sr. and his wife, B.A. Huffstutler, opened a hardware store in the mid-1930s. They also owned the Homewood Lumber Company (below), merging the two in 1949 to form the Homewood Paint & Hardware Company. In 1974, the business went to T.W. Huffstutler Jr., and Huff Rental was begun in 1988. Huffstutler's (above) eventually became affiliated with Ace Hardware, but it dropped the "Ace" name when it changed locations due to the development of SoHo in 2004. (Both, courtesy the Huffstutler family.)

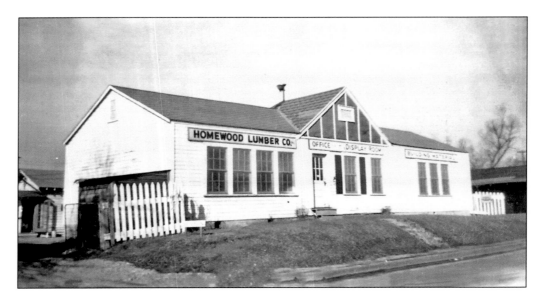

The *Shades Valley Sun* was a local newspaper that began in the home of George Watson at 1804 Mayfair Drive. After outgrowing that space, it was relocated to downtown Homewood, on the north side of Twenty-Ninth Avenue South. Owned by Watson, the *Shades Valley Sun* and its files have provided invaluable information for the completion of this book. (Courtesy BPL.)

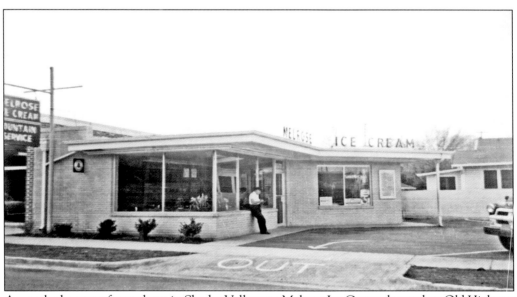

A popular hangout for students in Shades Valley was Melrose Ice Cream, located on Old Highway 31, across the street from Shades Cahaba. After school, students would walk across the street to enjoy ice cream before heading home. This structure is now the office of Ted Townley, of State Farm Insurance. (Courtesy BPL.)

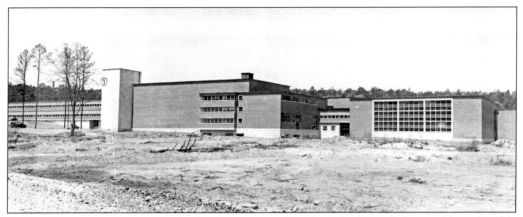

During the postwar boom, city leaders began to realize that Shades Cahaba would not be able to keep up with the growing population of Shades Valley. They began to look for an alternative. Together, Homewood and Mountain Brook voted for a 5-mill tax for the support of the new school. In the spring of 1949, Shades Valley High School opened under the leadership of principal Frank A. Peake. (Courtesy Shades Valley High School.)

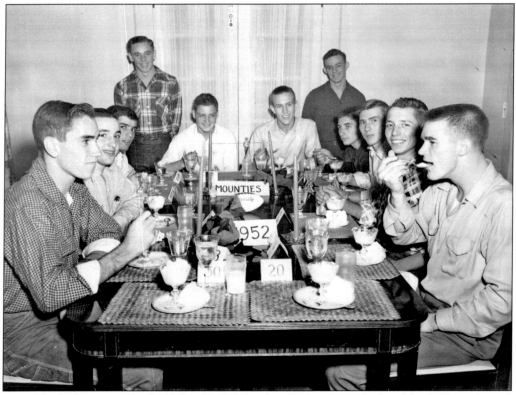

Piggy Mitchell went to Shades Valley High School in 1949 and was the head football coach until 1950. Norman Barrington followed Mitchell and was the head coach from 1951 to 1954. Players on the Shades Valley team are pictured here in 1952. Pictured are, from left to right, Roy Costner, Leon Valahos, James Dorsett, unidentified, Miller Gorie, Jack Kidd, unidentified, Scott Corley, Cactus Williams, R.G. Barnes, and Bob Hahn. (Photograph by Pierce Graves, courtesy WC.)

Ruth Hamner Yarbrough (left), Mary Williams Harris (center), and Elaine Ellard McDonald sit atop Kite Hill, where they discussed their future just days after they graduated from Shades Valley High School. Kite Hill was farmed in the early 1900s before becoming the site for Homewood Junior High School. When the new Homewood Middle School was built, the old junior high school was torn down, and the site has been turned back into a garden. Students from Homewood Middle walk this same path every day after school. (Courtesy Ruth Yarbrough.)

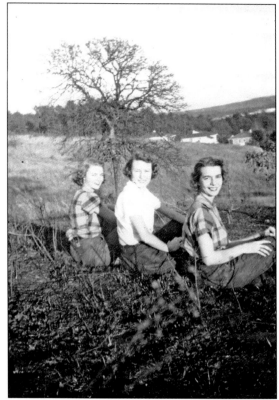

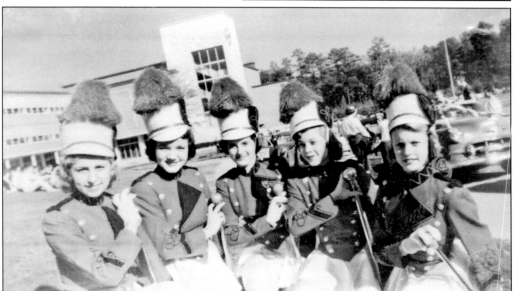

Shades Valley High School band girls celebrate Mountie Day at school. Mountie Day was the name given to the homecoming celebration. With the exception of the band members, everyone dressed like a mountaineer, which usually entailed overalls and long dresses, much like Daisy Mae and Li'l Abner. (Courtesy Shades Valley High School.)

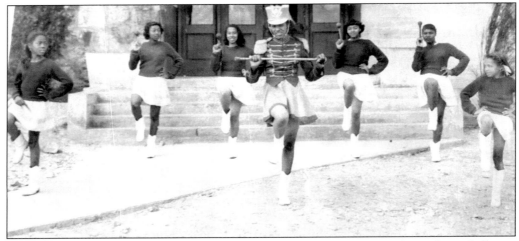

Rosedale High School offered an exceptional education for black students from all over Jefferson County, in the classroom and via extracurricular activities. Above, Rosedale High School band girls are, from left to right, Martha Bullard, Bettie Jackson, Ermatrude Montgomery, Lou Ellis Judkins, Lois Montgomery, Margaret Moore, and Dorothy Boggus. Below, Rosedale High School cheerleaders are, from left to right, Barbara Lawrence, Susie Clemons, Mattie Radden, Atetha Lowe, and Elliot Boggus. (Both, courtesy Pauleen Montgomery.)

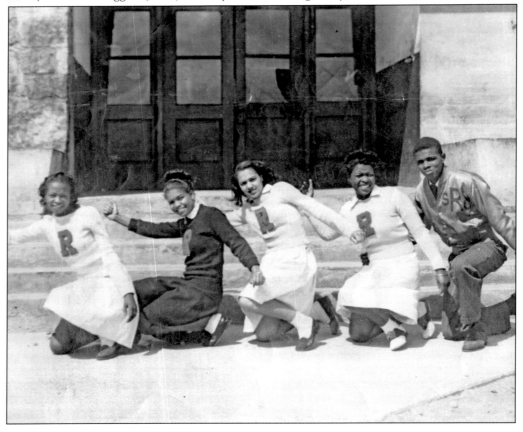

Morris Benson (right) presents Bishop Martienne "Fess" Montgomery and his wife, Pauleen, with watches upon Fess's retirement as principal of Rosedale High School. He served Rosedale School from 1926 to 1967. A native of Evergreen, Alabama, Fess was the first principal to purchase a bus, arranging for the transportation of students from Irondale, Mason City, Oxmoor, Oak Grove, and other communities. (Courtesy Edward Perkins Montgomery Jr.)

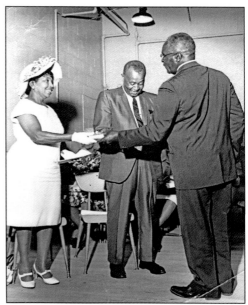

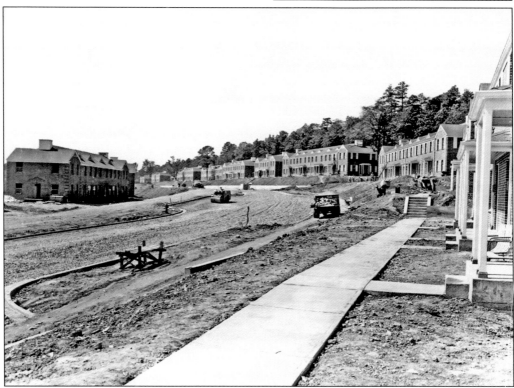

In 1948, the City of Homewood saw the need to provide housing for returning soldiers and their young families. Marge Clopton remembers moving in before her husband was sent to Korea: "the streets were nothing but mud." With new housing available, more young people began to move into Homewood. (Courtesy BPL.)

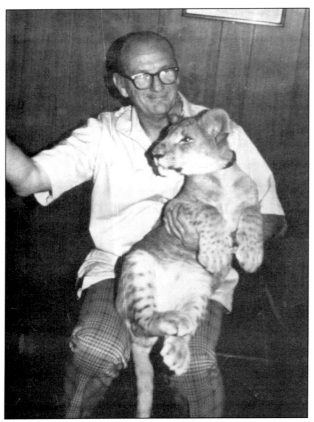

Dr. John D. Nall opened Nall's Animal Clinic on Central Avenue in 1949. He poses here with a rare white lion cub, King Solomon, in 1975. King Solomon was born at the Canyon Land Zoo, near Fort Payne, Alabama. Dr. Nall was also the veterinarian for the Jimmy Morgan Zoo in Birmingham for many years. (Courtesy Cindy Keller Burson.)

Dr. William Allen Standifer and his wife, Kathleen, opened the Standifer Animal Clinic in downtown Homewood on January 25, 1958. Kathleen kept the records of the business until she passed away in 2014 at the age of 89. Dr. Wayne Allen Standifer, the son of William and Kathleen, now runs the clinic. (Courtesy the Standifer family.)

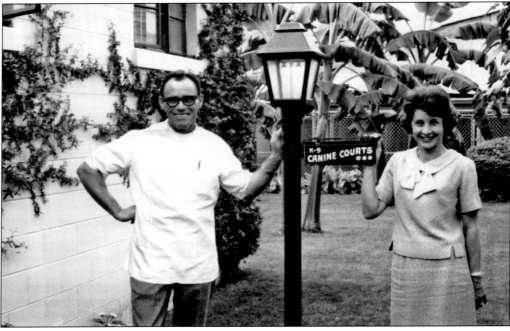

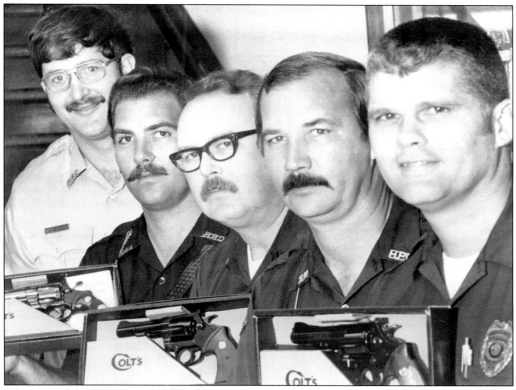

Members of the Homewood Police Department pistol team are, from left to right, Arnold Self, Paul Costa, Bill Thompson, Jim Atkinson, and Charlie Lane. In 1972, this team competed in the Southeastern Regional Police Pistol Match in St. Petersburg, Florida, sponsored by Colt's Manufacturing, and took four individual first places and fourth place overall. (Courtesy Charlie Lane.)

Chief E.H. Knox served the Homewood community as fire chief from 1927 to 1963. Recently, Homewood was able to purchase the original 1927 American LaFrance engine, which is now used in local parades. (Courtesy SCSU.)

your fire department...

Chief E. H. Knox
has been with the department for 36 years.

Howard Fields
Assistant Fire Chief and Fire Marshal.

Homewood's efficient fire department has increased in manpower and equipment.

The number of the department personnel now stands at 22. The department is headed by Chief E.H. Knox who has been with the city for 36 years. The Assistant Fire Chief and Fire Marshal is Howard E. Fields who, in addition to other duties, acts as fire inspector.

The inspector's main function is fire prevention, and the number of alarms has dropped noticeably since this service was instituted.

All trucks are equipped with the latest fire-fighting equipment including fog nozzles and a variety of extinguishers for different types of fires. Also available is a resuscitator to aid not only in any asphyxiation cases but also pulmonary illnesses.

Homewood enjoys a National Board of Fire Underwriters Class III rating, as low as there is in the state. This means that insurance rates are also as low as any other city in the state, equalled by only two others in the state.

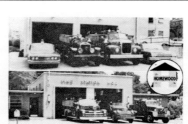

This shows equipment of Homewood's Fire Station No. 2 located at 430 Carr Ave.

Homewood's Fire Station No. 1 is located at City Hall and has efficient equipment.

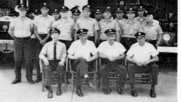

Personnel of Homewood's Fire Department, consisting of Station No. 1 and Station No. 2. Both stations have efficient staffs and equipment.

Homewood Church of Christ began meeting in 1951 in a small building on land donated by the late B.P. Williams of Woodlawn Church of Christ. In 1955, the congregation constructed this facility at 2917 Central Avenue. By 1975, that property was sold, and a new facility was built at 1721 Oxmoor Road. In 1985, that property was sold to Homewood. It is now the site of Homewood Library. Homewood Church of Christ now meets at 265 West Oxmoor Road. (Courtesy WC.)

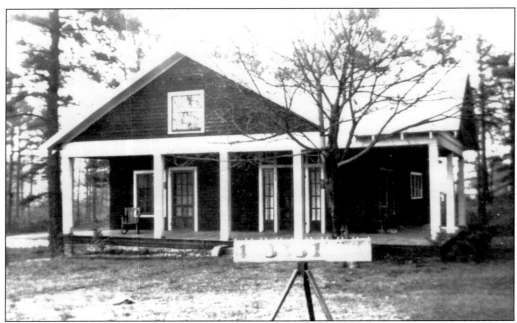

Our Lady of Sorrows Catholic Church moved to Homewood in the early 1950s, after its building in downtown Birmingham burned down. The congregation began meeting in this house, formerly the Cox home, until a building could be erected. Our Lady of Sorrows runs a K–8 school, and the Knights of Columbus have had a massive July 4th celebration every year since 1950. (Courtesy BPL.)

As Dawson continued to grow, the need for a new sanctuary became evident. Dawson purchased a surplus war chapel, but that could not accommodate the amount of people coming to Dawson. This photograph shows the Fieldstone Building (center), the Army chapel (right), and the current sanctuary under construction. (Courtesy Dawson Memorial Baptist Church.)

Because it had outgrown the two sanctuaries pictured here, Trinity Methodist was experiencing a similar postwar boom and also purchased an Army chapel. In the 1970s, the current sanctuary was built; Trinity now occupies the entire 1400 block of Oxmoor Road. (Courtesy Trinity United Methodist Church.)

As downtown Homewood and Edgewood became more crowded, the 1950s brought a move to the west of Homewood with the annexation of Oak Grove. Oak Grove Cumberland Presbyterian Church is pictured here at its original location on the corner of Oxmoor Road and Greensprings Highway. The church later moved to its present location on Old Columbiana Road, close to the old Griffin house. (Courtesy Charlie Lane.)

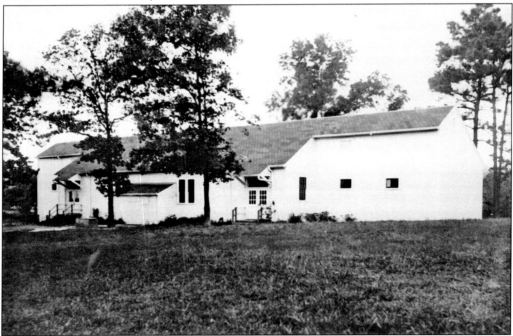

Named after Rev. James Hugh Blair Hall and the Kent family, Hall Kent was a county school in Oak Grove before being assimilated into the Homewood City Schools system in the early 1970s. The original school was in a converted barn, which tragically burned down in 1965. There have since been several additions and renovations to accommodate the growing population in west Homewood. (Courtesy Jefferson County Board of Education.)

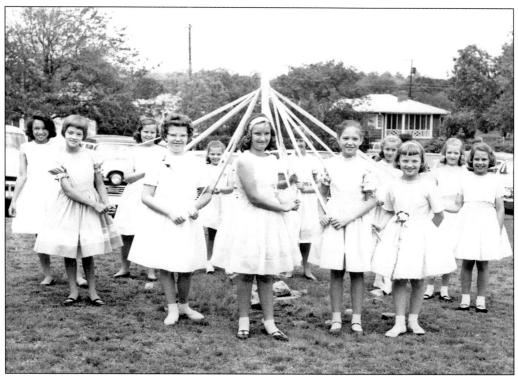

A maypole is a tall, vertical pole decorated with streamers or ribbons that are held by dancers to celebrate May Day. Above, schoolgirls perform circular dances around the pole to wrap, and then unwrap, the ribbon. Below, along with the May Day celebration, students from each grade would perform specific dances on the outdoor basketball courts on the southwest end of the school. (Both, photograph by Pierce Graves, courtesy Hall Kent School.)

Johnny Howard lived in this house along the old Oak Grove Road. The road used to run through what is now Wildwood North (near Lowe's), down to the Jefferson County Water Treatment Plant. Howard sold the land that is now West Homewood Park, under the condition that the land be used as a place for kids to play. (Courtesy BPL.)

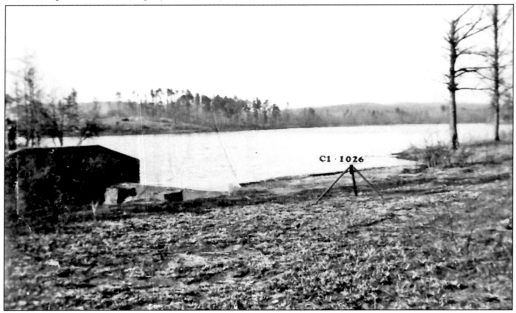

Edgewood Lake was not the only lake in Homewood in the first half of the 20th century. Oxmoor Lake, created by damming a natural spring, was southwest of the present site of Waldrop Stadium, where the parking lots of the businesses adjacent to Weygand Field are located. The lake was drained during World War II. (Courtesy BPL.)

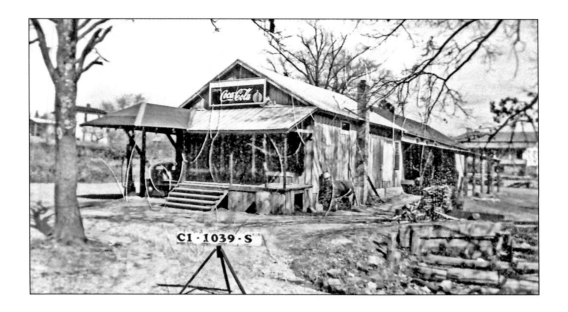

In Oxmoor Valley, members of the Goodwin family operated a general store (above), then known as the Goodwin Mercantile Company. Built in 1911, the store not only served those working in the mines, but the community as well, by taking telephone orders one day and delivering the next. The store was in operation until 1957. Happy Hal Burns ran the antique store before it became Pyburn's Emporium. Ralph Pyburn used to tell stories of a stagecoach robbery that happened in the store. Mrs. Goodwin laughed at the story, saying such an occurrence would have happened long before the store was built. Below, this house was torn down years ago, and the site is now a kudzu patch along Happy Lane, just behind Oxmoor Valley Orthodontics. (Both, courtesy BPL.)

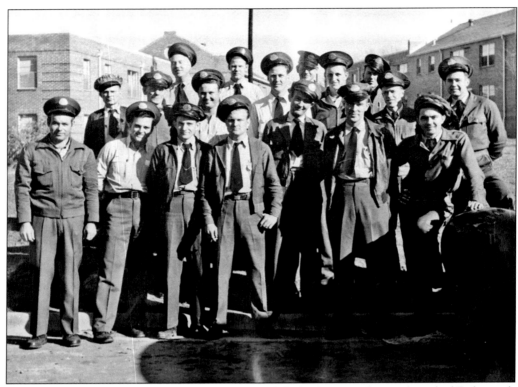

The original post office for the city of Homewood (below) was at the south end of Eighteenth Street. Even today, a post office box remains on the corner, just behind the funeral home. In the above photograph, Pierce Graves (third row, first on left) poses with his fellow postal workers near the Homewood Garden Apartments on Hallman Hill. Among the workers pictured are S.Z. Bailey, J.A. Hull, A.S. Ramsey, D.L. Cash, M.L. Morton, Dave Winton, and Eugene Adams. (Above, courtesy WC; below, courtesy BPL.)

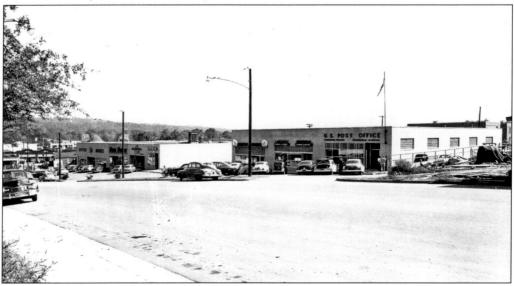

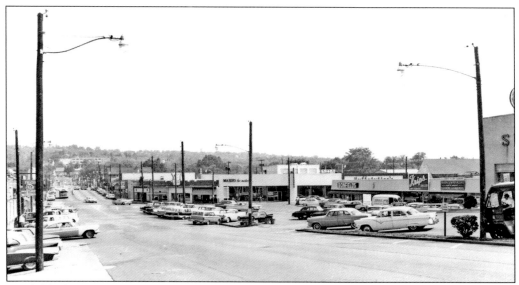

Bonfields, located on the southwest corner of Eighteenth Street and Twenty-Seventh Avenue, was a family-owned women's clothing store. To the south, up the hill, were a barbershop, Krips Shoes, and American-Peerless Cleaners. By the time this photograph was taken, the A&P grocery store had moved to the building today occupied by At Home. (Courtesy BPL.)

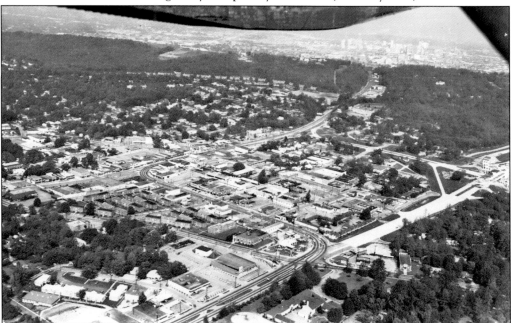

This 1969 aerial photograph of the intersection of Old Highway 31 and Twenty-Seventh Avenue shows the curve of Highway 31 through downtown Homewood before the completion of the Red Mountain Expressway. Unfortunately, due to the construction of the expressway and Highway 280, Homewood lost several landmarks, including Union Hill Methodist Church. Perhaps the biggest impact was the split of Rosedale, which drastically reduced the size of the historic neighborhood. (Courtesy BPL.)

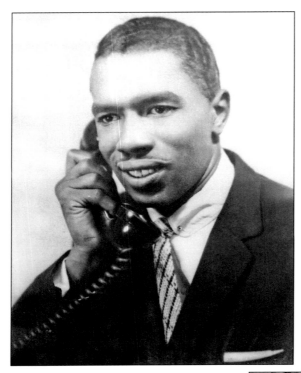

Shelley Stewart (left) witnessed the murder of his mother when he was only five years old. After being left in an empty lot, he found his way to Union Baptist Church in Rosedale, where he met a teacher named Mamie Labon Foster (below). Foster had a profound impact on Stewart's life. At his graduation, when they called Stewart's name, Foster stood up and said, "That's my boy!" Known as "Playboy," Stewart would go on to become a well-known radio personality. He used code words over the air to help civil rights leaders organize marches in downtown Birmingham. (Left, courtesy Shelley Stewart; below, courtesy Barbara Tubbs Pope.)

Three

GROWTH AND PROGRESS

This aerial photograph, taken on October 8, 1971, shows Greensprings Highway and Interstate 65 prior to much of the development that took place in the 1980s. The Hillcrest Country Club Golf Course, where the Palisades Shopping Center is today, can be seen between Valley Avenue and Oxmoor Road. To the west of Interstate 65 are the old ball fields, where many of Homewood's young men learned to play baseball. (Courtesy Homewood Middle School.)

In 1841, Samford University was founded as Howard College in Marion, Alabama. In 1887, Howard moved its campus to East Lake, where it remained until the postwar enrollment boom forced it to purchase property in Shades Valley in 1947. Howard College chose land on the north side of Lakeshore Drive, and the school was soon renamed Samford University. (Courtesy SCSU.)

Since 1947, Samford University has been an important part of Homewood. Set on one of the most beautiful campuses in the Southeast, Samford provides a quality Christian education with diverse undergraduate programs, as well as the Beeson Divinity School, Cumberland School of Law, and the McWhorter School of Pharmacy. Reid Chapel (pictured), on the east side of Samford's quad, is one of the most beautiful chapels in Shades Valley. (Photograph by Pierce Graves.)

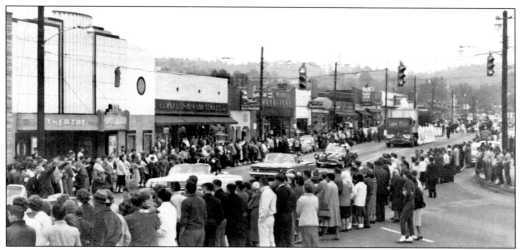

In the 1960s, Samford held its homecoming parades in downtown Homewood, along Eighteenth Street. School spirit was high, as Samford experienced early success in football, winning a national championship in 1971 by defeating Ohio Wesleyan in Phenix City, Alabama, by a score of 20-10. In the background at center is the Anchorage, a well-known breakfast restaurant. (Photograph by Lew Arnold, courtesy SCSU.)

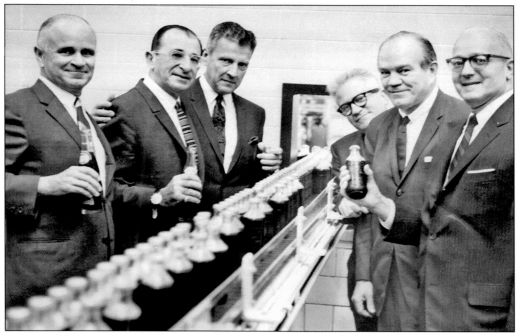

In 1964, the city council created Homewood's Industrial Development Board. By 1980, some 596 acres of newly incorporated land in west Homewood was attracting not only light-manufacturing companies, but warehouse and distribution centers, as well as headquarters for major corporations. One of the companies that took advantage of this was Buffalo Rock. James "Jimmy" C. Lee Jr. (far left), owner of Buffalo Rock, made a gutsy move in the 1960s by switching to nonreturnable bottles. He purchased a 15-acre site on Oxmoor Road to build a plant that could bottle a larger quantity of products. (Courtesy Buffalo Rock.)

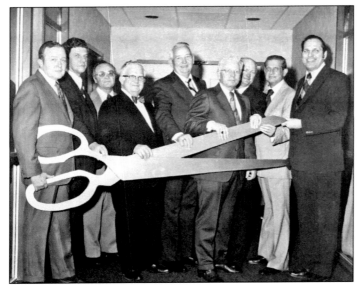

Seeking to offer exceptional health care with high standards for quality and service, the Brookwood Medical Center was founded in 1973 on the north slope of Shades Mountain. Brookwood houses the first women's hospital in Alabama and has been serving the "over the mountain" community for over 40 years. Here, Mayor Robert Waldrop (center) attends the ribbon-cutting ceremony at the new hospital. (Courtesy Homewood Middle School.)

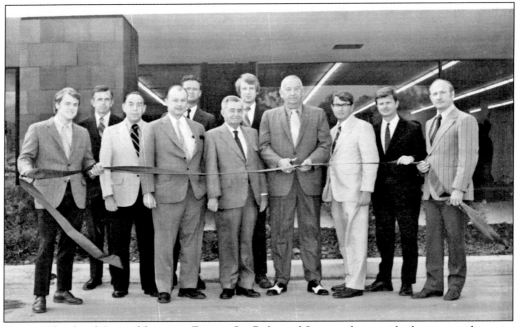

Everett Shepherd Sr. and his sons Everett Jr., Bob, and James, along with their second cousin Charlie Sharp, had the vision of building a mall between Highways 280 and 31, along Shades Creek. In 1972, they built a convenience center that housed a grocery store, drugstore, and movie theater. Pictured here at the ribbon-cutting ceremony are, from left to right, (first row) Sam Dewey, Brannon Crawford (main architect of Crawford, Giatinni Architecture firm), Everett Shepherd Jr., Everett Shepherd Sr., Robert Waldrop (mayor of Homewood), Jimmy Shepherd, Robert Shepherd (superintendent of the project), and the unidentified superintendent of the project; (second row) Riley Stewart (vice president of Brice Construction), Charlie Sharp, and Brian Mitchell (chief architect of the mall). The owners of Brookwood Mall development are Jimmy Shepherd, Robert Shepherd, Everett Shepherd Jr., and attorney Charlie Sharp. (Courtesy the Shepherd family.)

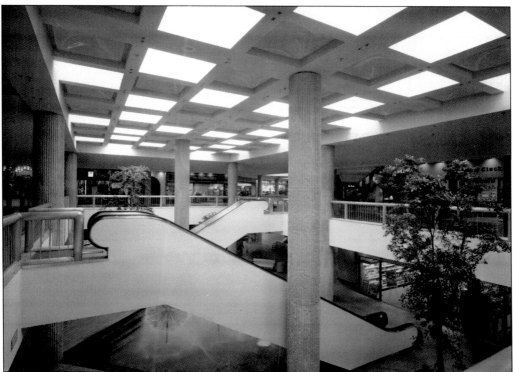

While the convenience center was being built, plans were made to construct a major mall just to the east. Rich's of Atlanta was the first major department store to commit to the mall, and Pizitz followed shortly thereafter. Part of the mountain was blasted away, and rocks were moved closer to Shades Creek. Rocks from the cut at Red Mountain were also brought over and placed in the swampy lowlands in front of the creek. Despite draining a swamp, cutting down a mountain, buying and swapping land, and various other obstacles encountered, the mall was built and leased in one year, just two years after the opening of the convenience center. The mall had its grand opening in August 1974. (Courtesy the Shepherd family.)

In 1920, Mr. and Mrs. Loo Choy, Mansion Joy, Leo Bing, and George Sai, all from Canton, China, started the first Chinese restaurant in Birmingham. Visiting the Joy Young Restaurant was a tradition for Homewood Junior High School social studies classes. In 1980, Joy Young moved to the Brookwood Gallery, a half block from Brookwood Mall. (Courtesy Henry Joe.)

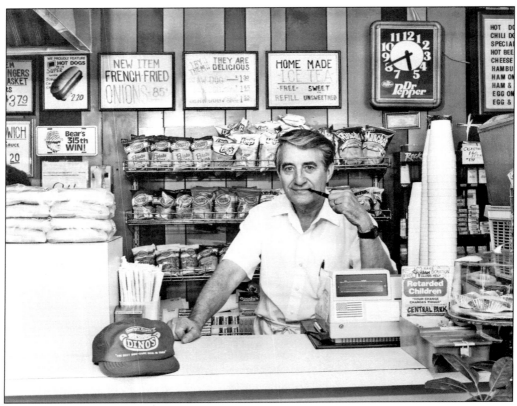

Aleck Gulas (above) and his wife, Helen, ran Dino's Hot Dogs in the 2900 block of Eighteenth Street in downtown Homewood. Known for his delicious chili dogs, Gulas also had a plentiful supply of Dum Dums and Dubble Bubble gum for all the kids. (Photograph by Andrew Tyson.)

Sam (left) and Pete Graphos opened Sneaky Pete's Hot Dogs in the old Homewood Barber Shop location on Eighteenth Street in downtown Homewood in 1969. After 10 years and much success, Sam and Pete franchised the restaurant. Sam, still longing to be in the business, changed the name of his store to Sam's Super Samwiches, and he has been serving the best hamburger in town since. (Courtesy the Graphos family.)

Herb Trotman opened his music shop in downtown Homewood in 1974. In 1976, he moved to 2906 Linden Avenue, where his shop remains today. Before guitars were available on the Internet, Fretted Instruments was one of the largest Martin guitar dealers in the Southeast. Trotman learned to play the banjo from Jim Connors on Sand Mountain and has been a large part of the folk music scene ever since. In 2010, Trotman was inducted into the Alabama Bluegrass Music Association Hall of Fame. (Photograph by Andrew Tyson.)

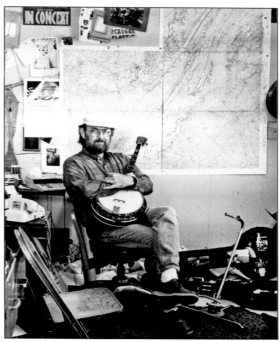

The Lowenbrau Haus opened in the 1960s in the basement of the Jack and Jill store on Eighteenth Street in downtown Homewood. Owner Pete Alexiou was convinced by Richard Lochmiller and Jim Connor to build a stage and to provide microphones and a spotlight. The only entrance to the club was a small, narrow staircase in a back alley behind the building. It was a small, intimate club that captured the folk craze of the 1960s. The band Three on a String (pictured) started at the Lowenbrau in the early 1970s, eventually moving to the weekend slot. People would show up as early as 6:30 p.m. for the 9:00 p.m. show. Pictured are, from left to right, Jerry Ryan, Bobby Horton, and Andy Meginniss. (Courtesy Jerry Ryan.)

In 1968, Afton Lee became the first African American elected to the Homewood City Council. He was elected from Ward One. In 1984, his daughter Adrienne was elected to the city council. Afton, pictured here in the early 1980s in front of his store, ran D. Lee & Sons Grocery on Eighteenth Street in downtown Homewood until his tragic death in 1989. Soon thereafter, the Rosedale Community Center was renamed the Afton M. Lee Community Center. (Photograph by Martha Wurtele.)

In the early 1950s, Demetri Nakos came to the United States from Greece at the age of 28. He opened up a restaurant, El Rancho, in downtown Homewood and ran it from 1961 to 1973. In 1973, he opened up Demetri's. It has been serving the best breakfast in Homewood ever since. Pictured, from left to right, are Demetri, former fire chief Al Evans, and Sam Nakos. (Courtesy Sam Nakos.)

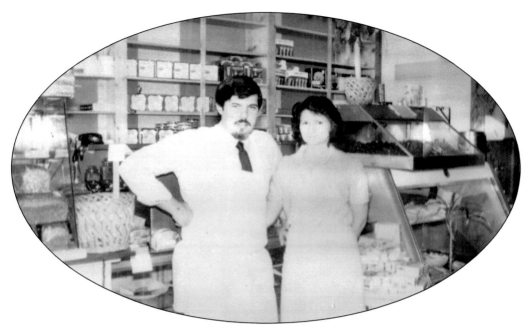

In 1975, three years after their marriage, Cameron and June Carr opened O'Carr's Delicatessen in downtown Homewood. O'Carr's is known for simple foods presented elegantly in a cafeteria setting. At O'Carr's, the motto is "Eat by Color"—customers are given a wide variety of foods, which is part of a healthy lifestyle. (Courtesy the Carr family.)

Zoe's Kitchen was founded by Marcus and Zoe Cassimus in 1995 on Twenty-Ninth Avenue South near Highway 31. They worked five days a week for 11 years before retiring and leaving the business to their son John. Zoe's now has 142 locations in 16 states. (Courtesy the Cassimus family.)

Unable to find a "truly great cup of coffee in Birmingham," Dr. Henry Bright, a retired orthodontist, opened O'Henry's in 1993 in the old Shades Valley Bank building on Eighteenth Street in downtown Homewood. After much research, Dr. Bright realized that he needed to not only buy the best beans in the world, but also roast them himself. His was the first coffee company in Birmingham to do so. Dr. Bright sold the establishment to Randy and Mary Adamy in 1999, but, to this day, O'Henry's buys and roasts its own beans at O'Henry's Coffee Roasting Company, also in Homewood. (Courtesy Randy Adamy.)

Around 1977, the Gaglianos opened Lag's Eatery on Broadway Street where it intersects with Carr Avenue. Gerard DeFrank took over in 1998 and ran the store until he retired in 2009. Lag's was always a popular place for the Homewood football coaches on Saturday mornings after a big win. Today, the store is occupied by Jo Jo's on Broadway. (Photograph by Andrew Tyson.)

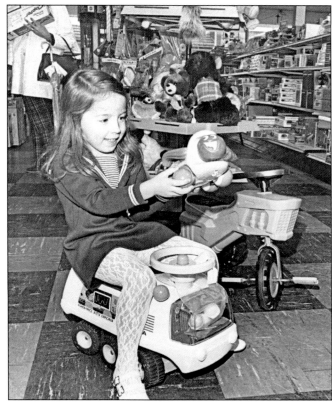

Tricia Busenlehner, pictured at right in Homewood Toy & Hobby in the 1970s, is now the owner, having taken over from her father, Walter. Tricia is a third-generation business owner. Albie Winkler, shown in the below photograph with Walter Busenlehner, was known as "the train lady." Homewood Toy & Hobby still specializes in model trains. Winkler knew more about them than anyone else. (Both, courtesy the Busenlehner family.)

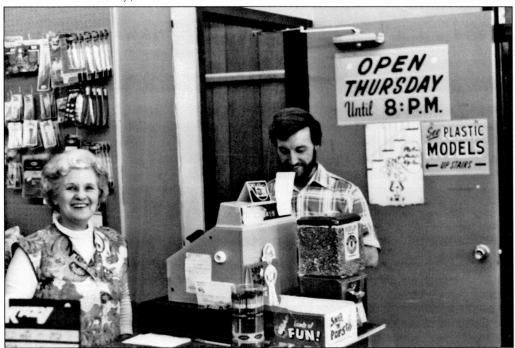

In the 1920s, Solomon and Sallie Monseur built a house on their property on Oxmoor Road. By 1930, the road was widened and a shopping center planned. The Monseurs turned their house around to face Stuart Street and built stores on Oxmoor Road. Zane Monseur married Philip Harris, and their three remaining children own the property today. Edgewood businesses located here today are Short n Sweet, Edgewood Creamery, Homewood Pharmacy, Dreamcakes, La Bamba, and SAW's BBQ. (Courtesy BPL.)

Original owners Sam Sicola (left), Tony Pardi (center), and Sal Pardi stand outside Trilogy Leather, at the former location of Duddy's Pharmacy, on the corner of Oxmoor Road and Broadway Street. Growing up together in Ensley, they have been friends since they were young. After giving college a chance, all three decided they would rather work with leather. Today, they are known for fine leather craftsmanship and handmade goods. (Courtesy Trilogy Leather.)

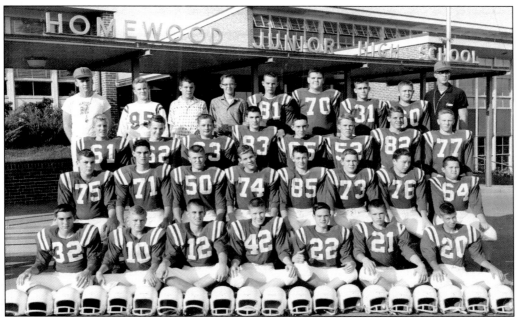

The Homewood Junior High football team, the Indians, is pictured here on October 15, 1959. Shown are, from left to right, (first row) Fred Boswell, Bill Huxford, Bob Kerr, Walter Schor, Allen Rogers, Eddie Propst, and Charlie Fisher; (second row) Mike Gonzales, Tommy Haggerty, Bill Meadows, Gary Griffith, Kenneth Peters, Lyle Key, Burton Kibble, and Chad Baker; (third row) Chris Collins, Bob Hewes, Terry Barth, Larry Chapman, Kenneth McEwen, Hugh Alford, Donny Andrews, and Larry Gwin; (fourth row) coach Pat Upton, managers Johnny Smith, Bob McDonald, and Orin Ford, Clint Bolte, Jim Burton, Travis Hartill, Jim Hutton, and coach Joe Ruffner. (Courtesy Homewood Middle School.)

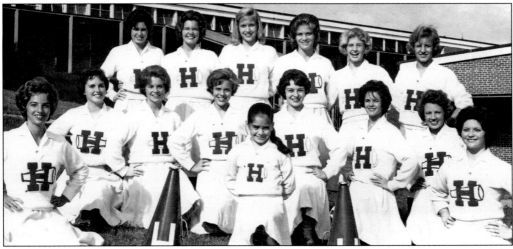

In 1947, Homewood citizens voted for a 5-mill tax; part of it went to the construction of the Homewood Junior High School in 1957. Here, the Homewood Junior High Indian cheerleaders pose outside the school. Among those shown are Mary Duffey (first row, left), Bari Allen (first row, center), JoAnn Davenport (first row, right), and Sherry Llewellen (third row, second from right). (Courtesy Homewood Middle School.)

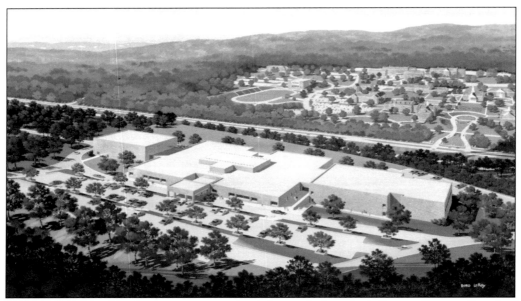

Homewood spent decades investing in schools beyond what the Jefferson County Board of Education could do. Finally, on December 22, 1969, the city council established the Homewood City Board of Education. Homewood Schools came together in 1970 under the leadership of Supt. G. Virgil Nunn. His top priorities were to decrease class size and emphasize fine arts. Homewood approved a special 5-mill tax to construct the new high school, which opened in December 1972. Michael Gross was its first principal. Until the high school opened, grades 1–7 had been attending Edgewood, eighth graders attended school at Trinity United Methodist Church, and those in ninth through twelfth grades used the junior high school. (Courtesy SCSU.)

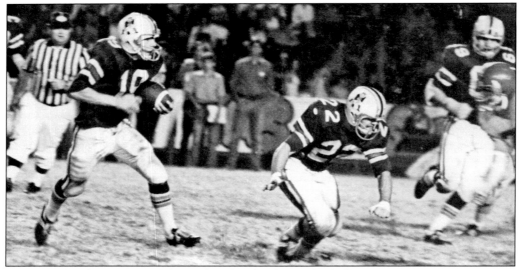

Homewood and Vestavia Hills have played each other in football every year since 1972. Here, in the first matchup between the two schools, Bill Holmes (19) runs behind Mike Haltiwanger (22) as Dean Snow (69) looks on. For 12 years, beginning in 1988, the away team won every game. The streak ended in 2000, when Homewood achieved an incredible 34-24 victory on its way to a state championship. (Courtesy the Powers family.)

In Alvin Bresler's third year as head coach, the Patriots saw their first region championship, their first playoff appearance, and, ultimately, play in the 4A state championship game, defeating Dothan High School at Legion Field on Saturday, December 7, 1974, by a score of 10-7. Several players from that team went on to have successful college football careers. (Courtesy WC.)

HOMEWOOD HIGH SCHOOL PATRIOTS
1974 ALABAMA 4-A STATE CHAMPIONS

Homewood went through four coaches over the next four years before hiring Gerald Gann from Berry High School in 1979. Gann guided the Patriots to the state title game three times (1986, 1990, and 1994). In 2000, he was inducted into the Alabama High School Athletic Association Hall of Fame. Pictured here with University of Alabama head coach Paul "Bear" Bryant is the coaching staff from the fall of 1982. Shown are, from left to right, Wayne Sheets, Bob Newton, David Jones, Bryant, Gerald Gann, Rip Harmon, and Dickey Wright. (Courtesy Gerald Gann.)

"Pride, Perfection, and Professionalism," the key attributes of the Homewood High School marching band, have made it one of the most recognizable marching bands in the country. Homewood has been named by the National Association of Music Merchants as one of the best communities for music education every year since 2007. Today, almost one-third of the student population at Homewood High School participates in the marching band. (Courtesy Homewood High School.)

Homewood High School boasts one of the best fine arts programs in the country. Pictured here are teachers in the fine arts department. They are, from left to right, Margo Burgess, Buddy Wade, Cindy Wade (dance team instructor), Daryl Ussery (choral director), Annie Laura Burton, Pat Morrow (band director), Mike Hawthorne (principal), Kathy Worthington Burnside, and Jeff Burnside (middle school band director). (Courtesy Cindy Wade.)

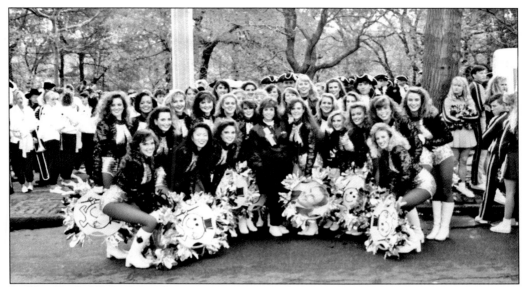

Led by Cindy Wade (center) from 1972 to 1997, the Star Spangled Girls is one of the most recognizable dance lines anywhere. The uniforms have stayed relatively unchanged throughout four decades of dancing. Jennifer Ayers (first row, far left), seen here as a Star Spangled Girl, is now the dance teacher at Homewood High School. (Courtesy Cindy Wade.)

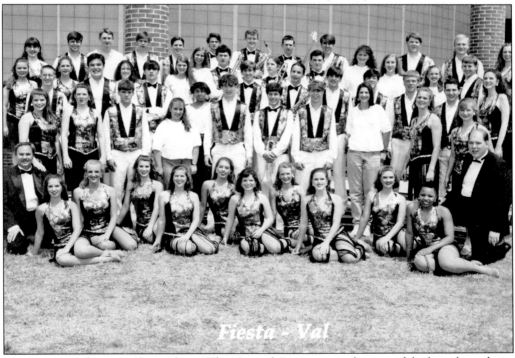

The Homewood Varsity Show Choir, "The Network," is recognized as one of the best show choirs in the Southeast. Pictured here in 1994, this choir performed "Standing Outside the Fire," "Jenny" (guys' number), "Why Haven't I Heard from You" (girls' number), "One Song," and "My Love Is a Fire." (Courtesy Leigh Lewis.)

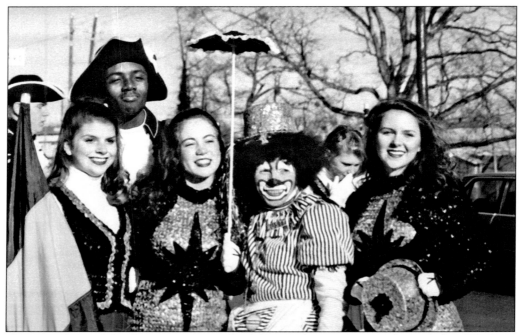

Homewood City Schools participate in all of the parades in Homewood—including We Love Homewood day, the homecoming parade, and the Christmas parade. Above, Homewood High School Band members Leigh Majerik (left), Brian Harrell (second from left), Katy Brown (third from left), and Carey Dickenson (far right) pose during the Christmas parade in 1993. Below, Homewood celebrates the 1995 state championship football team with a parade. Bob Newton took over the football program in 1995 and guided Homewood to six state title games, winning five of them from 1995 to 2005. (Above, courtesy Leigh Lewis; below, courtesy Keat Litton.)

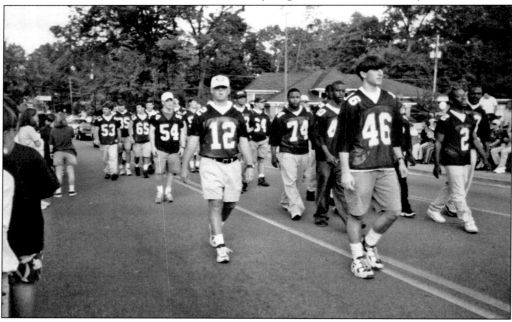

After years of baseball being played at West Homewood Park, plans were made in the mid-1990s to clear the swamp to the southwest of Homewood High School and build one of the finest baseball stadiums in the Southeast. Longtime head coach Bobby Statum threw out the first pitch at the new stadium, with Mayor Barry McCulley (left) and board of education president Jim Methvin (right) looking on. (Courtesy Bobby Statum.)

Dr. Jody Newton (left), Dr. Byron Nelson (center), and Dr. Bill Cleveland celebrate at the foundation dinner in 2015. When Dr. Nelson became the superintendent of Homewood City Schools, he hired Newton to be his assistant. They came up with a way to raise more money for the schools, adding a 1¢ sales tax and developing the first strategic plan in 1995. Without the leadership of the superintendents, Homewood City Schools would not be the great school system it is today. (Photograph by Scott Butler.)

DISCOVER THOUSANDS OF LOCAL HISTORY BOOKS
FEATURING MILLIONS OF VINTAGE IMAGES

Arcadia Publishing, the leading local history publisher in the United States, is committed to making history accessible and meaningful through publishing books that celebrate and preserve the heritage of America's people and places.

Find more books like this at
www.arcadiapublishing.com

Search for your hometown history, your old stomping grounds, and even your favorite sports team.